IRRADIATED CITIES

MARIKO NAGAI

LES FIGUES PRESS

Irradiated Cities
FIRST EDITION
Winner of the 2015 Les Figues NOS Book Contest, as selected by lê thi diem thúy.

Text and cover design by Les Figues Press.

ISBN 13: 978-1-934254-67-7
ISBN 10: 1-934254-67-3
Library of Congress Control Number: 2016962539

Les Figues Press thanks its subscribers for their support and readership.
Les Figues Press is a 501c3 organization. Donations are tax-deductible.

Thank you to each of the following individuals for assisting with the NOS contest: lê thi diem thúy, Teresa Carmody, Coco Owen, Sean Pessin, Divya Victor, and Andrew Wessels. In producing this book, special thanks to Julian Smith-Newman.

Inspired by the author's donation of a portion of her honorarium to Save the Children Japan, Les Figues will also donate a portion of the proceeds from the sale of this book to the same organization.

Les Figues Press titles are available through:
Les Figues Press, http://www.lesfigues.com
Small Press Distribution, http://www.spdbooks.org

Post Office Box 7736
Los Angeles, CA 90007
info@lesfigues.com
www.lesfigues.com

For D.

Bethink thee of the albatross, whence come
those clouds of spiritual wonderment and pale dread,
in which that white phantom sails in all imaginations?

-Herman Melville, *Moby Dick; or, the Whale*

Table of Contents

Irradiated Cities

We don't need more museums that try to construct the historical narratives of a society, community, team, nation, state, tribe, company, or species. We all know that the ordinary, everyday stories of individuals are richer, more humane, and much more joyful.

–Orhan Pamuk, *The Innocence of Objects*

HIROSHIMA

<<Tu n'as rien vu à Hiroshima. Rien.>>

Epicenter

34.39468N 132.45462E

: enough : enough has been told again & again : now, it's iconic, offering no space for an alternative : (but then, maybe there never was an alternative) : the day, August 6, 1945 : it is a clear day : (it always seems to be clear on catastrophic days) : there is no cloud in the sky : an ordinary day, a perfect Eden in memory & in nostalgia : mothers, fathers, children eat breakfast, then leave for school or work or their daily chores : in the *before* time, mothers are always beautiful, & fathers are always strong & kind : it is hot because it is August, & August is brutally hot in this southern city : it is peaceful because there is no cloud : it is ordinary : enough has been described about the *before*, their lives untouched by the days to come, yet : because it is a clear day, the city is chosen : (the nation at war : the nation about to surrender) : a silver plane at 32,000 feet, brilliant as their lives, made more brilliant in memory : let's go back to the beginning : the raid siren goes off, then stops : people stop, then go about their day : it is a beautiful morning, & all is well : then the flash : (the dead do not talk about the flash) : *pika* : before : then a second of silence as if the earth has taken a breath : then the blast : *don* : (the dead do not talk about the blast) : after : shards of glasses, walls, windows, debris, bodies, dishes in their hands & houses they live in : ordinary things become weapons : one second, people are there : the next second, they are gone : one second, a man walks on a bridge : the next second, he is a shadow left behind in the moment of his next step : one second, a woman walks with a parasol in her hand, her dress white with small flowers : the next second, the flowers press against her skin, her back becomes the field of flowers, or the page of the exotic specimen of flora : one second, an intact face of a man : the next second, it melts, where his mouth once was, his eyes, & where his arms should have been, gone : underneath the epicenter, gone : they all say that after the *don*, the world becomes, for an elongated second, devoid of sound : the silence is what they remember : then the cacophony : fire on the ground : a city disappears between a *pika* & a *don* : the survivors are no longer individuated but become a new species : *hibakusha* : the story begins : the story of the everafter starts : their story of *before* & *after* : *before* 8:15 a.m. : *after* 8:15 a.m. : the story where enough has been told : enough has been said, from the ground & the sky, from the offices of the faraway land & the near-enough land : but the dead cannot talk : the dead do talk by the objects they leave behind : stones sing their irradiated songs & enough will be said about this moment for years to come : but maybe it is not enough : there is never enough in this everafter story of one bomb & another bomb & the illumination of the night : & the silence :

Refracted Sky of the Epicenter

A February Sunset

8:30 a.m.

: they come to : they come to after the *pika* & *don* : the unfamiliar landscape, the strange new logic of familiar objects : glass bottles wilting, bending as delicately as flowers or acrobats : beams & concrete slabs collapse like waterfalls : the dead walk aimlessly & the living are lost : they say the silence, the eerie silence after the *don* : then the fire, always the fire : the dead cannot talk : fire engulfing the living : fire swirling in a vortex, alive like an injured creature, thrashing out in pain : when they come to, a different landscape : a father is trapped under a beam in the burning fire, & he tells his children, *go, leave me here, go* : a horse runs around, spraying blood with each step, then buckles & it is dead : a tram full of people in various reposes of their morning commute : a morning full : a morning's work done for the men up in air, making their way back to Tinian Island : a ladder is now a memory, only a shadow imprinted on the wall & next to it, a man, any man would do, his shadow left behind as if to say, *I was here, & I'm still here* : a mother leaves behind her children trapped somewhere under the roof, they are calling to her, they are crying for her : but the fire is threatening to engulf her : & she can't move the house to get to them : *it's so hot, mommy, help me, help me* : & she runs away, tripping over bodies intact & mangled : fire everywhere, one path of wind colliding with another wind, creating a vortex in the middle : a little boy comes back to the land of the living on the back of a strange soldier, being carried through fire toward the rivers & he sees naked people, & he himself is naked : always the rivers : people ambling toward the rivers, their flesh melting from their bones : faces burnt off : a student remembers sitting in the classroom one moment, & coming back to consciousness in the schoolyard, having travelled through the air while she blacked out : *I'm so thirsty, please, water, water* : but no one gives water, no one can & you're not supposed to, besides : the rivers : people crawl toward rivers, any rivers : they jump from the bridges : they roll down the banks for water, to cool down, to get away from fire, but the rivers have disappeared : rivers are filled with bodies : those who can walk try to walk home, the instinct of a homing pigeon, home, where things are safe, home, where everything makes sense : rivers clogged with bodies : rivers stay still : houses burn : the rain falls, & it is black, but they still open their mouths to quench their thirst : the quiet : that's what they say : they say that they remember the sun disappearing that day : they remember how quiet it all was in the devastated city :

Oota River

The Living Calls to the Dead

: the city simmers from above & from the ground : houses keep collapsing : rivers stink from decaying bodies : survivors hold each other up because everything else has collapsed : schools : concrete buildings : what used to be hospitals : they stagger : in a day : in two days : people start arriving in the city looking for their loved ones : children wander around the streetless streets looking for where their homes used to be : people arrive with water & food, going from one skeletal building to another : calling : always calling : *have you seen…?* : *have you seen my husband? he works here* : *my children went to school here* : floors of buildings covered with the wounded & the dead : nights do not come : the sky never darkens : the white nights alight with fire from the ground : *have you seen…?* : a charred woman leans against a wall, her face bandaged : someone has written her name above her : she is not anonymous : she has a name : people flock to this city after the bomb, looking, looking for their loved ones : there is no water : there is no medicine : the city keeps burning : the city burns : people keep calling to each other : they take still-hot nails, pieces of broken glass, & scratch messages on walls still intact : *I'm alright* : *we are evacuating to…* : *come to… as soon as you read this message* : *Uncle & Cousin looking for you…* : they carve names & words if by chance the missing see them : bodies after bodies arrive at schools & hospitals, brought by strangers or families : doctors, as wounded as patients lying in bathrooms, corridors, closets, decide who is worth saving, who must be let go : *the corridor that day & days following was covered in blood, you kept slipping on blood that flooded the floor* : handwritten signs where houses used to be : anonymous bodies in various degrees of burn & shock : *I hurt, Mother, I hurt* : a child without a mother : a child without a name : which mother is he referring to? : which child calls to which mother? : does not matter : it is all children calling to all mothers : there is nothing left to treat the body in pain : they are let go : the carvings on the walls : people walk amidst the rubble, going from one shelter to another : looking : always looking : looking past because they don't recognize the face behind the burn : looking past, then looking at : bodies carried to the yard once they are done for : laid out on streets : flies claim them soon enough, already unrecognizable faces become swollen with heat & maggots : the dead moving with lives underneath : the smell : after the day of bonfire : this is what people say : they say that rivers cease to flow : they say that they remember the smell of bodies still burning under the collapsed roofs, smell of bodies dismantling under the summer sun : bodies lying unclaimed : searchers walk amidst the dead & the dying & the city that was but no longer, looking for something, anything familiar : a name tag : a rumor of sighting : anything & everything : they walk : they walk all day : they keep scratching messages : it is another hot day in August : it is still a clear day : they do not know that their bodies now carry a bomb inside : a ticking bomb :

Atomic Stain

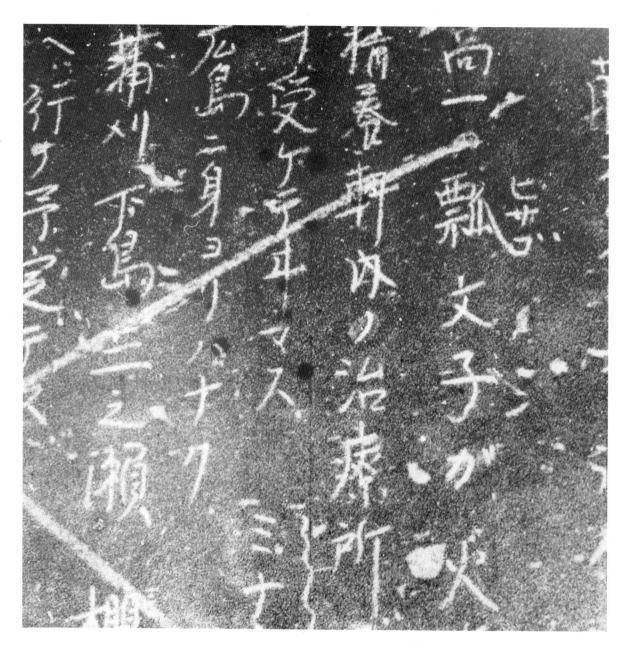

Writing on the Wall

Hiroshima Red Cross Hospital

This Mysterious Disease

: first, the healthy bodies : it is always the healthy bodies, the ones without burns or wounds : they are the ones who came out of that day without a scratch : they are the ones who came out to the city the day after, looking for the missing : & they are the ones who came home, staggering, & their families sighed in relief that they weren't harmed : first, the healthy body : a boy, fourteen years old who made it back home from his school, 1000 m from the epicenter : the first symptom : nausea : perhaps a cold, or exhaustion : a trifle illness, negligible & treatable with a good rest : vomiting lasts, though : it lasts longer than it should : the unease : the city burns still in the periphery of their vision : vomits all day & night for five nights & he aches all over, he says : he cannot eat : he cannot keep anything down : they take him to a place where there is medical help : he is still conscious & there is no wound anywhere on his body : he says he hurts all over as another bomb detonates in Nagasaki : nine days after the bomb, the voice of the Emperor floats through the radio, announcing the surrender of the Empire : ten days after the bomb, *findings of blood: hemoglobin: 70%, red cells: 4,060,000, white cells: 4,200* : he's given a Vitamin B shot : eleven days after the bomb, *hemoglobin: 70%, red cells: 4,140,000, white cells: 1,200* : something is happening inside his body : next day, his white cell count is down to 700 : he is given an injection of 50cc of his own blood into muscle & a transfusion of 100cc type B blood : something is dismantling him from within : hair keeps coming out in fistfuls, & he is sleeping more : bloody nose & erupting ulcers on his lips : he cannot keep anything inside his body & lies there in his own vomit & diarrhea : things are breaking down inside, the body is collapsing from inside out & they don't know what it is : was it poisonous gas? : they wonder : the rumor of gas, just like in the war in the second decade of this century, when men became paralyzed & mute & blind : is it typhus? : is it a plague? : they wonder : bacteria : twenty days after the bomb, he is nearly unconscious : his body keeps erupting from within : specks as small as pinheads & as large as peas appear all over his body, swelling more with each hour : these purplish bruises float to the surface of the skin & stay, like floating leaves : with each & every day many patients like him arrive, whose bodies are without wounds but slowly change into canvasses of specks : he has lost so much of his hair already : his eyelids are covered with bleeding specks : the inside of his mouth rots : he dies twenty-one days after the bomb : his family, if they hadn't seen this metamorphosis, this decay, would not have recognized him : the doctor opens him up & inside the body, a universe of bleeding specks & disappeared white cells : outside, bodies lie side by side in the yard to make space for the living : bodies wait to be cremated : the city has cooled down : now, the city smells of unclaimed bodies rotting, claimed bodies unable to be cremated : bodies wait, both the living's & the dead's :

Shadows in the Hiroshima Peace Park

A God's Messenger

Impermanent Shadow

The Americans Have Come

: Americans come in jeeps & ships : they come through the rubble still uncleared : they bring with them instruments & cameras : the city in rubble, uneven, demarcation between houses & streets unclear & the land covered with unclaimed bodies : the flies beg to be pushed away : they swarm around the bodies, the air starts humming from their buzzing : the smell rises from the ground & Americans hold their hands over their mouths, looking at a landscape that looks more like a painting, that's what they tell themselves, that it looks like a painting of hell : they carry boxes of equipment & measuring instruments : they step atop bodies that explode under their feet : they walk & chew gum as people look at them with unseeing eyes : these men in khaki sometimes laugh with unease because that's what people do, just as that's what men did during the war, laughing as they shot the enemy : they measure the shadows left behind on walls & bridges : they point at the angle of the shadows to calculate the direction of the bomb : they tsk at the smell, how shameful, these people haven't cleaned up the bodies : they photograph the wall with the shadows of the ladder & the man : they step on charred objects that used to belong to a person : they get the numbers of how many students died in each school : Hiroshima City Girls High School 10th grade, 277 students, 11th grade, 264 students, 0.6 km from the epicenter, all dead : Hiroshima City First Middle School 9th grade, 40 students, 0.9 km from the epicenter, all dead : same school as above, 7th grade, 44 students, 1.3 km from the epicenter, all dead : & they can see the effect of the bomb, they can see how resilient the human body is against this new weapon they have created : they go into the skeletal hospitals & shake their heads : (no medicine, not enough doctors, unhygienic, these people don't know modern medicine, do they?) : people who look like rags : corridors that smell of blood & feces & decay : people too much in pain to moan & people keening for the dying : the vacant eyes : doctors & nurses who are as wounded as their patients, who sleep in the bloodied corridors & on the floors of the flooded latrines, there is no distinguishing between the living & the dying : syringes used again & again & bandages have to be pulled off from the dead & reused without washing : the smell of rot : Americans hold their mouths & noses as their interpreters explain the autopsy results : their hands move fast, taking notes, taking photos of patients, telling them to move around so they can get a better shot : they tell a nurse to pull up a limbless person & take one shot, then another : they tsk their tongues : they go back to their jeeps thoughtfully : it was a small bomb: it was a small bomb from the sky, they saw the mushroom cloud : but now that they are on the ground, they can see what it can do : they tsk their tongues : as they drive over the bumpy road, they say this won't do : they will bring in heavy machinery & flatten the ground, with unclaimed bodies & debris & rubble so that they can drive smoothly next time they come to this city :

Shadows of Hiroshima Peace Museum

Irradiated Bark

How to Treat That Mysterious Disease

: (we swear, it will make you better) : press the Japanese silver leaf on your face burn, make sure to carve out holes for your eyes & nose : drink bark of the dried cherry blossom trees : burn papers as effigy, & mix water & ash & paste it on your burns : grind human skulls & drink the concoction, or smear it liberally on your burns : eat dried squid : drink the blood of a cow : eat seaweed & shellfish : grind cucumbers & put the paste on your burns : drink as much green tea as you can : eat persimmons : pop blisters with razor blades : smear pumpkin juice on your burns : burn moxa atop your head : eat oysters that Hiroshima is known for (but remember, oysters live in the sea & that's where all the bodies went) : drink *dokudami*, that taste of old tobacco, we swear, it will do wonders : open up an eel & paste it on your forehead : treat your burns with cooking oil or sesame oil : apply zinc oxide olive ointment on swollen areas : drink milk : submerge yourself in a hot spring bath : let maggots infest your wounds : smear cow shit on your wounds, you will never get keloids : drink as much as you can (drink for the pain, drink for the escape, drink to feel better) : eat liver, raw or cooked : take calcium pills : ask for a 100cc blood transfusion every day or every other day : drink bone marrow soup : eat pears, eat many pears : drink vinegar : eat, put your fingers down your throat, & vomit : eat *umeboshi* : eat dried earthworms : drink the blood of a carp, the fresher the better : apply charred bones of animals on your burns : smear urine on your wounds : drink lots of salt water : put salt on your navel, then a mound of miso paste atop that, & burn moxa : eat figs : drink mud snail juice : drink as much miso soup as you can : (we swear, it will make you better) :

Calm Is the Sea of Hiroshima

No One Talks About It, No One Can Talk About It

: effects of these bombs are silenced : they exist on the ground of Hiroshima & Nagasaki : proof on bodies : proof visible : but to the rest of the world, what these bombs can do is never reported : destruction is abstract as long as there are no pictures, as long as there are no testimonies, as long as there are no visual testimonies : two bombs obliterated one city, then another, but that's all most know : that's all anyone is supposed to know : no one outside knows that the cities are completely obliterated : that the land is littered with skeletons still in the various poses of their landing after the *pika*, made permanent with the *don* : the Americans came & observed : they took notes, they recorded : the Americans came & told the journalists, *don't write about this* : they told the Japanese doctors & journalists, *don't ever publish a word of this* : photos taken by a photographer only three hours after the bomb are confiscated & disappear in the box of an archive on the different continent : no documentation, no history : but people talked : all over Japan, they knew that some sort of special bombs had been dropped on Hiroshima & Nagasaki : & as soon as they began to witness people, so wounded, so tattered, escaping from these two cities, people began to talk : look, they are carrying some sort of disease : look, nothing would grow in Hiroshima for the next seventy years : look, I heard that they become strangely lethargic & then they lose hair & die soon after : look, they are in so much pain : but the rest of Japan has its own personal tragedies to deal with : what happened in a city far away : what happened in the cities so far away can be kept at bay, & what cannot be known is only a phrase whispered from one person to another, until the original story is warped, exaggerated, monstrous : as long as it did not touch them, people went about their days trying to survive : trying to find food : trying to find the will to live : trying to find those they lost : & those who could talk were trying to survive : the dead cannot talk, the dead do not talk : the silencing from within & without : no one can write about the landscape of what happens after this bomb : Americans have a new enemy : this bomb is a state secret, it is an important secret : the world equilibrium hinges on no one knowing : no one can know except for the creators of these bombs : so Americans keep collecting data, they keep gathering as much information as they can : how many people died where : how the body dismantles under radiation : how a city can be destroyed : how bodies stay alive even after irradiation : they observe : they nod : they write down symptoms after symptoms : for the bombs they made, & for the bombs they are making : this is all for the future wars they can wage against new enemies :

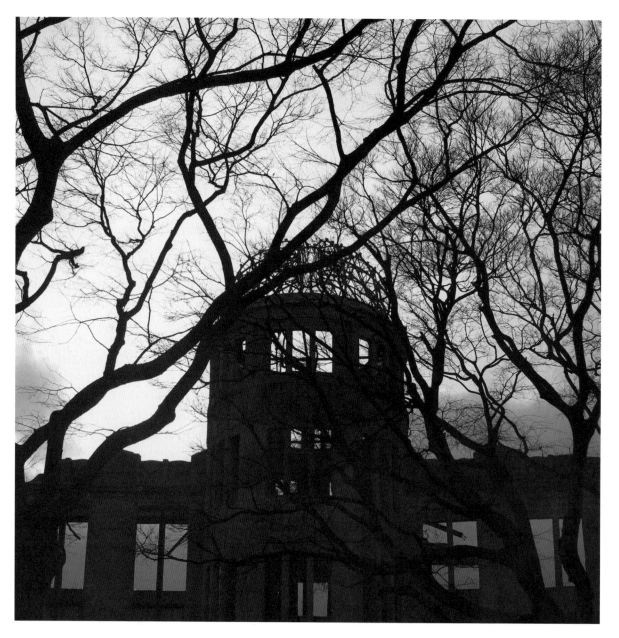

Hiroshima Atomic Bomb Dome

Atomic Bomb Slum

: this is what happened : where we used to live, overtaken by strangers who lie & tell us that they've always lived here : (we are only children, our parents still missing, we are only wives though there have to be husbands in order to be wives, & how can we be wives if they are dead?) : we take shelter near the skeletal Commerce Building where all the displaced are : we take shelter near the epicenter because there's enough space : new houses are getting built : people walk around unscathed, laughing, wearing brightly colored clothing : (where did they get that? how did it survive the bomb when we didn't?) : women walk around with permed hair & bright red lips in the arms of the former enemy : they pose in front of the rubble, tourists to our tragedy : Americans take photos of us, the more dense our scars, the more disfigured our tragedy, the better it seems : we build a shack out of anything, a shack big enough to fold our bodies in when it rains : it is by the Oota River that we can launder & throw our waste & wash ourselves : we throw garbage out of our windows & it piles up & rots : (just like the bodies of that day) : we make our living going through the rubble to find intact skulls, pulling out gold teeth or keeping just the skulls to sell to the Americans, & they buy anything, including suffering, on this sojourning to the land of the bomb : we do anything to survive when we are well enough, but most of the time our bodies are as heavy as lead & we don't know what to call this except for *genbaku-sho*, the atomic bomb disease : some call it *burabura-sho*, the loser's disease, because all we can do is do nothing but sit around : there is something living inside us : our children huddle in the corner in fear, in helplessness as the beast grows inside us : am I going to start losing my hair? am I going to start bleeding? am I going to die, leaving these kids behind? : so we drink as much as we can as we hear our next-door neighbors argue in Korean : their voices are alluring & incomprehensible : the houses huddle close like small animals looking for warmth along the river : a fence taller than us pens us in : the Koreans, the Burakumin south in Fukushima-cho, the widows & feral children : up & down the banks of the river, we all live huddling next to the water we so wanted that day : we are bound by our lacks : we are bound by our anger : we are bound by our suspicion of outsiders : they look down on us because we are not strong enough to rebuild our lives : they look down on us because we do not move away from here : they look down on us because they can't see beyond our shells we can't discard : we are strangers brought together by constant fear of when it is going to be our turn to die, just like we are supposed to : but what can't be seen, what can be ignored, does not exist, & in their narrative, we cannot exist : & just as the bodies were buried with rubble to flatten the land, they will come with their heavy machinery & flatten our houses to make way for a better city, a beautiful city, a fictionalized city called Hiroshima where grief is symmetrical : & we will have nowhere to go :

Ghosts of the Atomic Bomb Slum

Symmetrical Suffering

Hiroshima : ヒロシマ

: suffering is photogenic : a museum grows out of the cleared-out slums : a park rendered symmetrical, harsh edges of lawn & trees : irradiated trees for all to see : what is visible is here : the eternal fire & a girl with a crane : the narrative of the city is decided : calculated angles : tamed : translatable : ghost neighborhood underneath the park : a memorial : what does not fit the narrative is buried underneath : eradicated : the slums & its inhabitants driven out by power shovels & with them, their stories : yes, the stories of people pulling themselves from the rubble & persevering : instead, ヒロシマ is about broken bodies : a man sells his keloids, hard knots of flesh, to anyone willing to pay for a shot : the museum is filled with stories of how they died : pictures of the wounded bodies : everyday objects rendered barely recognizable : the children : the tragedy of children sells the best : it is the tragedy that sells : there is no alternative to the story of the bomb *they are selling the atomic bomb* : *they are begging for sympathy* : 廣島 : the old name for this city : before *pika & don* : 広島 : the neutral name : the main narrative must embody the following : the only survivor of the family, cut off from love & understanding : bodies a topography of gnarled flesh : young & innocent children lying in the hospital beds : a freak show of tragedies as if it were one hundred years ago, where the dying travelled in carnivals for pennies a glance : they must tell their stories with tears, emphasizing how alone they are : the word, *peace* : the word, *nevermore* : the city has become ヒロシマ : Hiroshima : synonym for tragedy : the first city : the only country to have suffered the bomb : tourists walk around with expected stories : stories come out, month after month, a Scheherazade to reinforce a narrative, an elegy that keeps going again & again until there is no alternative : every anomaly of the body seen with pity : *pika don* : pennies for suffering : photographed in hospitals : for the silent ones, there is no need to keep defining their lives as *before & after* : the silent ones are not just *hibakusha* but full human beings, who have pulled themselves out of the rubble of their home, this city, living their lives as best they know how : & more than anything, they want to name their death, they want to define their own death : they do not want *before & after & everafter* : it is not ヒロシマ they live in : they do not live in the fictional space called Hiroshima : this is their home, & this is their life : this city is not just ヒロシマ but also home to many more stories than what is visible : *you saw nothing in Hiroshima* : you did not see the sky without a sun that day : ヒロシマ has forgotten that this bomb was conceived by men, & used by men : you saw everything of the *after* & nothing of the *before* or the sky above or the desert where the first flash went off : you saw nothing in Hiroshima & you saw enough : yes, this is 広島 : this is Hiroshima : this is enough :

Hiroshima in Reverse

Notes

The quote in the subtitle of the 'Hiroshima' section, "Tu n'as rien vu à Hiroshima. Rien" is one of the repeated motifs from *Hiroshima Mon Amour* (1959) directed by Alain Resnais with a screenplay by Marguerite Duras. Photos were taken at various places in Hiroshima in 2013 and 2014.

NAGASAKI

<<It Is a Very Pleasant Way to Die>>

To the Epicenter

Phantom Epicenter

The Specimen Nagasaki

: this city : this city of priests & nuns : this city of church steeples & the Dutch blood : the entire city is a scientific specimen : the still-standing façade of the church : the cracked face of an angel : the shadows of men left on walls : *Stabat Mater*, the stone Mother without eyes, the stone Mother with an irradiated rain-tear down her cheek : a wooden clog with a name but without its owner : a dead girl's dress that an American scientist packed in his suitcase, worried that someone might open it & find him perverse for carrying a little girl's dress : a doctor's bloodied overcoat from *that* day : babies born after *that* day : a woman goes to ABCC & comes back with a medical record, & where it should've said *name of the patient*, it says *name of the specimen* : babies with no eyes, babies with squashed heads, limbless babies floating in vats of formalin as if they are still in wombs, waiting to be born : jars & jars of organs taken from the dead : rocks & stones, their testament to that day, boxed & stored in a university : a man claws at the straw mat, leaving four deep scars & jerks in pain in his small hut he calls home, while his children watch in the corner, holding their breaths, & a photographer hesitates & the man yells, *photograph me, photograph what the bomb did to me!* : a man stands in front of an atomic monument, charging money to tourists to photograph his keloid back : psychologists study the survivors & their ways of living : the world is catalogued, named, even their anger is named : names of the dead engraved in the gravestones, the date the same for all : 5592 bodies autopsied in 1948–1950 : even the second generation is there to study, to see the lingering effect of the bomb : the microcephaly kids, affectionately called *mushroom kids* by their parents, are examined but mothers are told that it's because of the mothers' diets during pregnancy, it's not the bomb : the specimen days : the hall of the dead with all the names of the dead, no matter how many years : the specimen years : organs float in jars with wooden number tags : numerated specimen : the city still stands as a testament to *that* day, years & years after : still in the shadow of the bomb : when will it be freed? : when will it be freed from the shadow? :

A Reminiscence of a Lost Church

The Flesh of Camphor

Before the Before & After the After

: they were told many things during the war : they were told many things : that Japan was the chosen one : that Japan was a sacred nation protected by a divine wind : that this country would never lose : to wear clothing that covered their arms & legs, to cover their heads with air-raid helmets & to wear gloves : to wear white clothing : to cover their eyes with four fingers & stick the thumbs into ears & to duck : never to let the burn victims drink water : (but they died anyway, with or without) : that a few days before August 9, 1945, fliers fell from the sky—just like the bomb—with a message, *Nagasaki is a good land the land of flowers Nagasaki will be the land of ashes on the 7th or the 8th* : & afterwards, they were told that dogs overran the cities & attacked the dead & ate the living : afterwards, they were told that 95% of the people who got radiated on those two days would die : afterwards, only five days after the Surrender, two cities were covered in wisteria : that once your hair starts falling out in fistfuls, you would die : that every woman on those two days spontaneously started menstruating : that all women stopped menstruating : that the more you drank, the more you were likely to survive, & drink you did, even the alcohol that was made of recycled gasoline & pure alcohol : that you can't live long if you stay in Hiroshima or Nagasaki : that plants grew better near ground zero : that people were finally freed from athlete's foot in these cities : that the atomic bombs *blew a hole & let in the light from a new possible world… a hope for new energy source, it's the dawn of the new world when humans can live like humans*[1] : that bodies went down the rivers toward the sea, just like all creatures going back to the saline past, & the clams ate the dead & we ate the clams : that the cities were rebuilt upon tens of thousands of bodies, the cities built upon bones, the cities stacked precariously upon the dead : that all women from Nagasaki & Hiroshima have something wrong with them : that babies born in the cities were missing parts of their bodies or, even worse, parts of their past : never get in the Black Car from ABCC, even if the money is seductive : never go into a hospital, you can never come back alive : never marry people from Nagasaki & Hiroshima because they carry within the possibilities of devastation, even after decades : that they were all right, they were healthy, & it's all in their heads : that their *after* lives are difficult & painful because they survived, because they left their loved ones in fire, because they didn't give *that* glass of water to the dying who begged for it, because they turned deaf to the pleas of their friends begging for mercy, for an easy way out or in, because they stepped on the bodies of the dying as they ran through the devastated terrain, because they are selfish, because they are still alive : that the bomb dropped on Nagasaki was God's way of punishing, because it wasn't enough that Jesus died long ago for their sins, & because they are human, they are sin : rumors thread into their stories : each retelling puts rumors closer to truth until truth & hearsay become one & the same :

A Shadow of the Bomb

A Remembering Stone

One-Legged Shrine

The Story of *Hibakusha*

: there is only one story for *hibakusha*, the irradiated people : there is only one narrative & nothing else : their stories must be tragic : their lives must be bound to loneliness & pain & loss : they must carry the visible wounds for all to see : their faces must be disfigured beyond imagination, their flesh knotted bark that climbs up & down the body unwanted : they must be told, at least once in their lives, that they cannot marry the ones they want to marry because they carry the possibility of monstrosity within themselves : they must have been ostracized by others, whether in the bathhouse or at the dentist's office, afraid they would bleed to death, or on streets or by the government : (*listen carefully, do you know how it feels to be walking down the street & men catcall, but as soon as they see my face, they run away screaming? do you understand how it feels that no one wants to rape me?*[2]) : they must have journalists & photographers stalking them during those two days, documenting their corporal tragedies : they must all experience strange deaths, unnamed & unnameable, deaths that are beyond understanding & the only way to explain them is by explaining them away with atomic bombs : they must be victims, they must be weak, they must be outsiders in the narrative of the postwar : (*if we say how our legs ache, our backs ache, if we say we would never forgive the atomic bombs & look sad, would people be happy? but we are not freak shows, we are all managing somehow; I'm so sick of tear-jerking articles, I'm so sick of talking about peace this, peace that; do they think that by writing about sad things, we the* hibakusha *would be happy?*[3]) : they are supposed to be blind : they are supposed to be deformed : they are supposed to sit by the windows of the Atomic Bomb Hospitals, papers folded into cranes to submit their pains & fears : they are supposed to be orphans or to have lost their families : they are supposed to be within the 3 km radius of the bomb that day in order to be considered *hibakusha* : they are supposed to have lost everything that day : but so many went on with their lives, with scars invisible, never telling their stories to anyone : they went on & they still go on, because there is no other way but to live, even if in guilt & shame : even if it is without words :

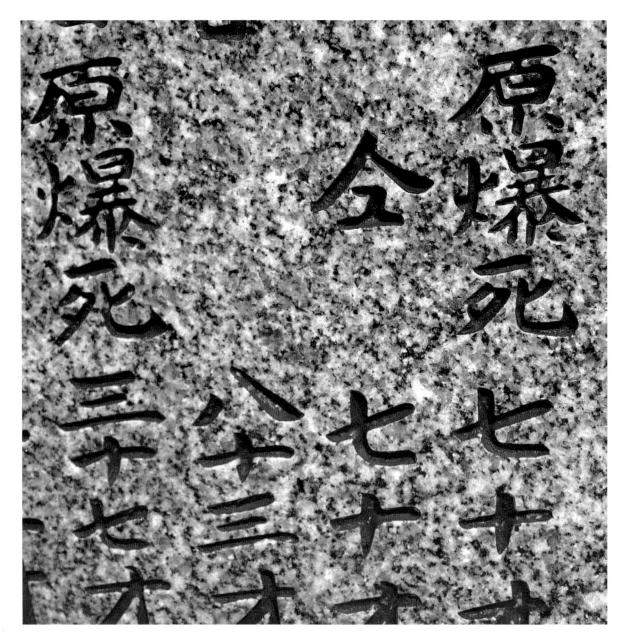

Deaths of a Family

A Sheltering Sky

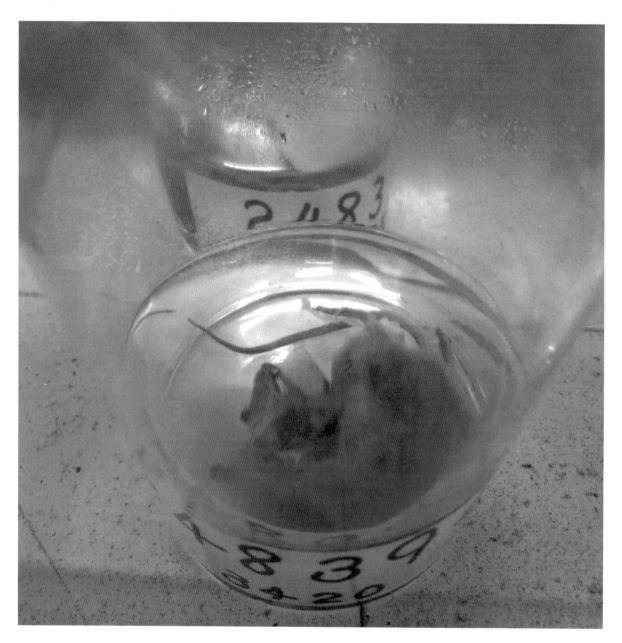

An Irradiated Rat

ABCC, or the Atomic Bomb Casualty Committee[4]

: the only car that drives through the unpeopled ruin is the car from *that* place : it drives over the ground groaning with unclaimed bones, it drives over the controlled decay, doctors & nurses come out in the darkest black with flowers, the only ones in this city who can still wear clean black & who still think flowers mean something in a place where small gestures have lost meaning : they knock on the doors of the recently deceased bearing gifts of sweet coaxing & money that is more practical than words : *sorry to hear about your loss, but would you mind giving us the body for autopsy? we promise we'll only take the organs out & return the body to you stitched up so you'd never know*[5] : & these words are seductive, & money is more so when hunger has become what defines you : & the body comes back a few days later : the grievers take the money so the dead can be properly buried, so the dead can have a gravestone above them because they can't do it for the ones lost *that* day : children are told to run away when the jeeps come tumbling down the streets : they are told never to get in the jeeps, or else : or else[6] : but some go for the money, for the yearning to get better, for the chance to ride in a car, any car : they drive up a winding road, up the hill & are taken to the American buildings so white & clean, yes, so clean : they are led to a room & told to change into robes so white it hurts the eyes : in this city, white is for the privileged few : they get their blood taken & urine tested : eyes examined & the body tested for parasites : asked about their location, how far away they were from the epicenter *that* day, whether they were inside or outside, & if inside, what the building was made out of : a mother takes her microcephaly child to *that* place, the child crying & crying because he is scared though he cannot articulate it, he can't say anything except to make animal sounds : they tell him to move this way, that way, to hold a position, while the camera keeps rolling & the mother is frightened by the Americans, by the machines that make loud sounds, by her child's fear : she makes her child do everything the doctors tell him to do, always the Americans commanding & the interpreters, in their halting Japanese, rephrasing : the mother is told that the child has microcephaly because the child absorbed all the radiation for her, *for* her : & she is devastated, there is no cure for her beautiful child, who will always remain an infant, prelinguistic & presocietal[7] : once, they brought girls from Kure, the ones who never experienced the bomb : doctors forced them to stand naked & measured their pubic hair & mounds : doctors noted their breast development : girls stood ashamed : girls stood with their eyes downcast while Americans looked with hunger in their eyes, not sexual, but hunger nevertheless, as if these girls are no longer individuals but something to examine, something to study, a new specimen a botanist can pull apart & claim as his own : & they are given one thousand yen in an envelope : they are told to eat better, to get blood transfusions, to take it easy : all the while the camera keeps filming, keeps filming & documenting :

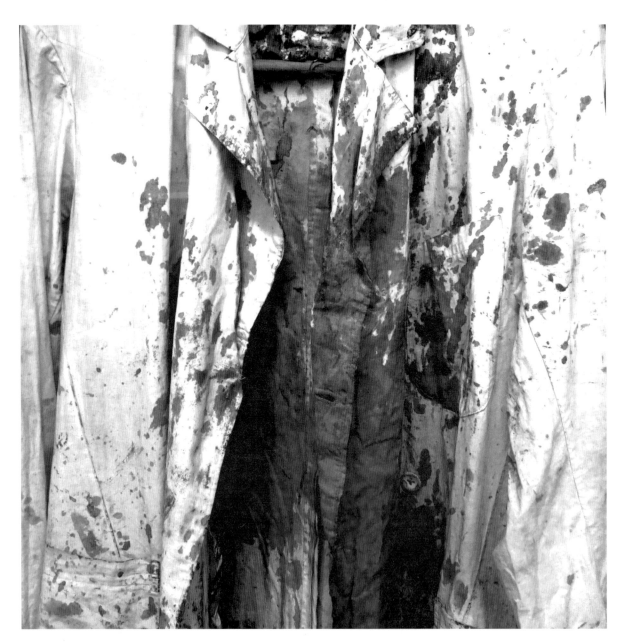

A Doctor's Coat from That Day

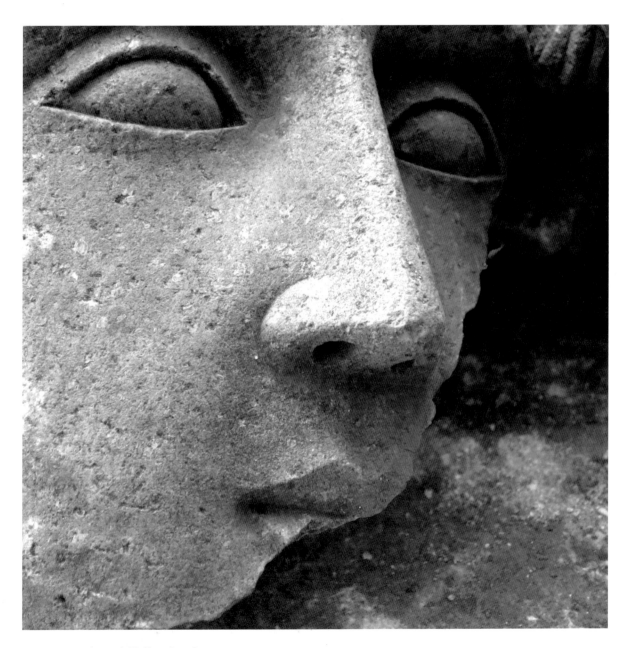

A Fallen Angel

What It Means To Be Irradiated

: it means that you carry the fear inside you : it means that no one sees you as a person but as a *hibakusha*, your life defined by *that* day : it means that someone else defines you : you must have been within 3 km of the epicenter : it means that you must have entered the city, whether Nagasaki or Hiroshima, within the first week after the atomic bomb : it means that you must have at least two people vouch for you, even if you lost everyone who knew you there on *that* day in *that* city : it means that you have to carry the green *hibakusha* card : it means that your words against those of anyone else have no meaning : (you were there, you know, but there is no proof) : it means to live with the fear, the constant fear of getting sick : a little nosebleed, & you fear the inevitable : a common fever, & you wonder : it means that your life is dictated by how you should be : a victim, yes, always a victim, always pitied, & you know that once you are an object of pity, you are at their mercy : it means that you have to lie in your life, you don't tell people where you were on *that* day, you tell others that your sickness is not related to the bomb : it means that you live your life not telling even your children that you were irradiated : it means that you fear going to the Atomic Bomb Hospital, *the examinations are scary, if it's because of the bomb, they'll make you stay at the hospital for the rest of your life*[8] : it means that if you ever get sick, you refuse to go to the hospital because you are the healthiest person in the family, & if you stopped working, no one else can bring in the money so you keep pushing & pushing yourself : it means that if you are a Korean, you aren't a *hibakusha* because in order to be a *hibakusha* you have to be Japanese : it means to live with the guilt of having survived : it means that you must have walked away *that* day when others were begging for your help : it means to wonder, every time you got pregnant, whether the new baby would come out healthy : it means that every time your child got sick, you blamed yourself for being there *that* day : it means that if you were disfigured from the burn, from the blast, you would stay inside the house, hoping to live out your life without being seen : it means that every year, when *those* days come around, photographers take your photos without permission, as if *hibakusha* lost the passport to humanity the moment they were irradiated : & you see the faces of these journalists & photographers, their eyes gleeful because the more scars you have on your face, the more tragic you look, the more they can elevate you into an icon : it means to be told by politicians & doctors to be sterilized so that there wouldn't be bad genes in the future : it means that you are now a specimen : it means that the rest of the time, no one cares about your life, no one cares about your illness, no one cares : it means that every time you walk down the street, people stare at your wounds, then look away as if by staring they, too, would become disfigured like you : it means that when you go into a restaurant, no one wants to serve you because they think you are contagious : it means that even the world-famous photographer will never shake your hand, no matter how many hours he spends photographing the most intimate moments in your life : it means that no one

understands why you feel aches & exhaustion for no reason, & others call you lazy & living on welfare : it means that while the cities were rebuilt & renewed, old buildings were razed & streets were paved, you felt left out from the progress : it means that you live the rest of your life as if on borrowed time : it means that you walk on the street, & no one seems to remember what you went through, what people like you went through, *that* day, & so many days & years afterwards : it means that when you speak of your experience, some will say that you are selling your tragedy : it means that you keep telling the story of *that* day again & again, that your voice sounds mechanical & your story soulless : it means that every time *those* days come, people flock to the cities & you stay in your home, & they give speeches in the self-congratulatory way & you stay silent, all these years, & you will stay silent until the day you die :

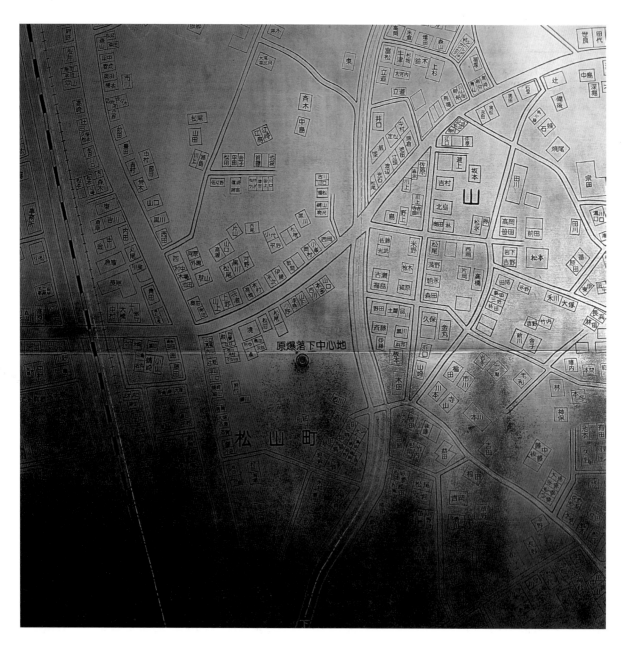

The Disappeared Neighborhood

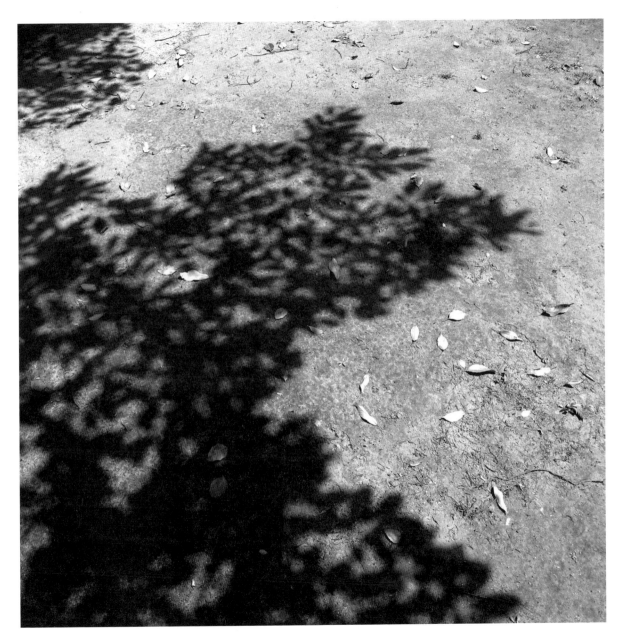

Temporary Shadow

Nagasaki Maidens

: *why them?* girls in Nagasaki wonder : *why were they chosen & not us?* : their faces had hardened into flesh masks, just like those Hiroshima Maidens : their hands had gnarled into claw-like shapes : their hands reduced to stumps at the end, just like those Hiroshima Maidens : then why? they wonder : their bodies, too, were scarred with hard knots & wounds, & no men would ever touch them : they stand & *smile* for the camera, & girls in Nagasaki wonder whether they have ever been photographed just like healthy girls, & wonder whether they'd ever smile, just like that, as if they are normal : Nagasaki has rebuilt itself, but their faces only grew into monstrosities : *with a face like this, I have no one who would marry me. I like children. I can't help but go over to babies being carried on their mothers' backs, but what do you think happens each & every time? all the babies cry like they are on fire & cling to their mothers in fear. you would never understand how miserable I feel every time this happens*[9] : they would never marry, they think : not just girls but boys their age have a hard time getting married if they were within 3 km of the epicenter : & no one wants to marry disease-carrying people : there are rumors about babies born fused together, or without arms, or with heads like cracked pomegranates : & with the girls' scarred faces, everyone knows that they were there *that* day : they aren't like other girls, they know that : if they do get a job, they are seated somewhere in the back & preferably in the dark where no one will be *offended* : they wonder if they can ever go outside without scarves around their heads to hide the scars on their faces as much as they can : they wonder if they can ever wear short-sleeved dresses, just like those Hiroshima Maidens, & walk outside without a care in the world : they wonder if they can sit under a tree with a boy whom they like, & hold hands shyly just like they've seen in the dark movie theaters where they could, just for a few hours, live a life with only one ending : a happy ending : they wonder why Hiroshima was chosen, but not Nagasaki : they wonder what makes Hiroshima so special, they wonder what makes those 25 girls so special that they could go to America, live like Americans they've seen only on magazine pages, & come back with better faces & perhaps brighter futures where anything is possible, where everything is possible :

An Irradiated Wall

An Angel

A Woman, a Child, & the Camera

: *like this* : a woman stands at 3/4 view, just like she would have been on *that* day, & the invisible camera reenacts the position of the bomb : a woman stands facing the invisible camera with her son strapped to her back : *the mother's face & entire body were burned, whereas only the child's legs, which were protruding, were burned*[10] : the camera-eye closes in on her face : the camera eye closes in on her child's legs : she looks unblinking at the lens, her face blank, & the camera eye stares back without emotion : *mother undresses with her child on her back. straps are removed from over her breasts to show unburned areas where the straps were at the time of the blast.*[11] : the camera looks & the woman stares back, she has not blinked, not once : her naked torso is red, because the film is in Technicolor & colors are unforgiving : the child's legs are shown, first his left leg, then his right leg, one foot fossilized in the shape of the hardened skin : *like this* : like a dead bird's clawed leg : *the child's face, which shows no presence of burns, contrasts with the bad burn scars on the mother's face*[12] : the woman keeps staring into the camera, half her face burned : she does not blink, she does not smile, her eyes fixed in front of her : she stares back at the camera, & her nipples become two eyes & stare back, unblinking, at the camera : the camera stares back : like this :

The Unclaimed Dead

A Hall of the Dead

August 9

: the city of priests & nuns & stone angels & hills : the city of the same God as the enemy's, but on that day, God was the God of Americans & not Japanese : the city of stone steps carved into the mountains, houses perched precariously on the sides : the city of climbing, women & men stopping in mid step to smooth their breaths & calm their beating hearts : the city of secret faith, the believers going underground for God, to deny God during the day while folding Latin liturgy into sutras to pray in the hidden rooms at night : the believers emerged after 300 years when the missionaries came back, *we believe in the same god* : the city of stone angels & red bricks : the city that took under its wings so many different languages & nationalities : the city said to be so close to Shanghai that *it was like going to a barber* : the city of prayer : the second city : the second city to be bombed : the second choice, not the first choice, even on *that* day : the city of gravestones all carved with August 9, their deaths named as *Death by Atomic Bomb* : the city that has forgiven the past because it knows that the past must be forgiven : the prayers for the survivors : the prayers for the dead : the sea takes them far, carrying them to Korea, to China, to Shanghai : & as the sea keeps going, as it knows not to stop, so has its history : so has the city :

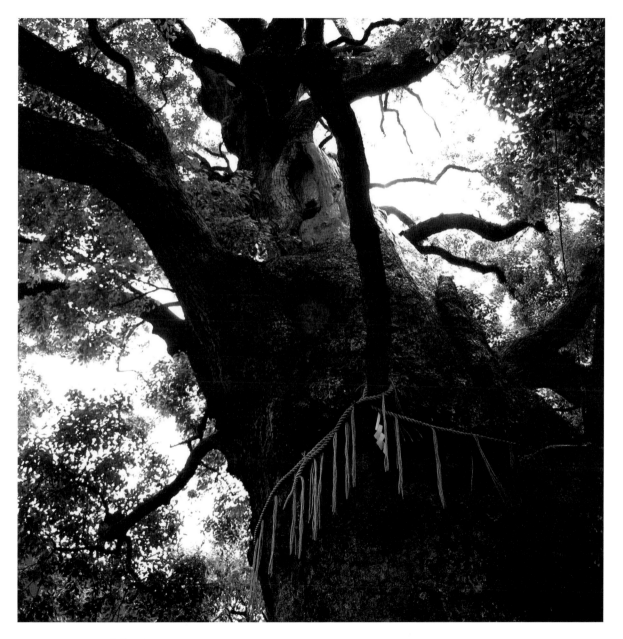

The Witness

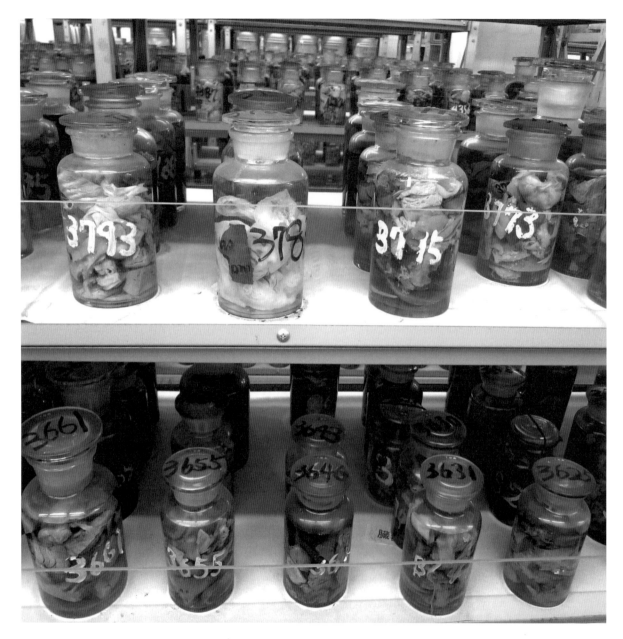

Tissue & Histopathology

Notes

The subtitle of the 'Nagasaki' section's subtitle, "It Is a Very Pleasant Way to Die" is taken from General Leslie Grove's testimony before a U.S. Senate committee in November of 1945. Photos were taken at various places in Nagasaki in 2013 and 2014.

1. Quoting Dr. Takashi Nagai. Kawamura, Minato. *Genpatsu to Genbaku Kaku no Sengo Seishinshi (The Psychological History of Atomic Bombs and Nuclear Powerplants in the Postwar Japan)*. Tokyo: Kawade Books, 2001 (115–119). 川村湊『原発と原爆　「核」の戦後精神史』河出ブックス　2011 (115–119).
2. Fukushima, Kikujiro. *Fukushima no Uso Utsuranakatta Sengo (Lies of Hiroshima: The Undocumented Postwar)*. Tokyo: Gendai Jinmonsha, 2003 (112). 福島菊次郎『ヒロシマの嘘　写らなかった戦後』現代人文社 2003 (112).
3. Nakajo, Kazuo. *Genbaku to Sabetsu (Atomic Bomb and Prejudice)*. Tokyo: Asahi Shimbunsha, 1986 (41). 中条一雄『原爆と差別』朝日新聞社 1986 (41).
4. ABCC stands for the Atomic Bomb Casualty Committee.
5. Nakazawa, Keiji. *Hadashi no Gen Watashi no Isho (Barefoot Gen: My Last Will)*. Tokyo: Asahi Gakusei Shimbunsha, 2012 (15). 中沢啓治『はだしのゲン　私の遺書』朝日学生新聞社 2012 (15).
6. Yamanashi, Tomoe, ed. *Kono Sekai no Katasumi de (In the Corner of This World)*. Tokyo: Iwanami Shinsho, 1965. 山代巴編『この世界の片隅で』岩波新書 1965.
7. ibid. (77–78).
8. ibid. 1965 (2).
9. Fukushima, Kikujiro. *Hiroshima no Uso Utsuranakatta Sengo (The Lies of Hiroshima: Unphotographed Postwar)*. Tokyo: Gendai Jinmonsha, 2003 (112). 福島菊次郎『ヒロシマの嘘　写らなかった戦後』現代人文社 2003 (112).
10. https://archive.org/details/USAF-11034
11. ibid.
12. ibid.

TOKYO

<<It Is No Longer the Postwar>>

Unsleeping City

Construction Time Again

This Brilliant City

: of the destroyed : this brilliant city that lives for its dreamed future : the city lay in ruins : then rebuilt, first shacks, then permanent : it moves forward as its inhabitants walk, not looking back : the war has been over for a decade : ten years, in this city, is another lifetime ago : buildings pop up like mushrooms after a rainy season : a man without legs sits on the sidewalk, wearing the white of the past : he begs, *I am a former soldier, have mercy* : people walk by, carrying their invisible losses & griefs : they do not look at him : (we all lost someone or something ten years ago) : another war has started in Korea : another war brews in Indochina : this brilliant city lives on the backs of wars : see that tower, Tokyo Tower, made out of decommissioned tanks from the Korean War : see that building : built from profits earned from wars close & far : roads are built over rivers : rivers lie fallow & forgotten : people do not look back : the hunger they felt during that war another lifetime ago ghosts their steps : they walk, trampling away the past : (we all lost someone or something ten years ago) : the sun rises : the sun sets : the city shines bright at night, eradicating the darkness : the city has conquered nights & darkness & the past : another man walks by in his construction worker's clothes : he sees the legless man in white : he carries with him an anger : *I lost my parents in the war : my father died like a dog on some South Pacific island, they said that he starved to death, & when you are starving, hunger consumes you : my mother died that night when Tokyo burned bright : she was trapped underneath a burning beam : I was only five years old : I couldn't lift the beam to save her : she said,* Go, go, leave me, or you'll die with me, go, go : *I cried & cried & no one helped me or my mom : I know hunger : I don't ever want to be hungry* : he walks by the legless man in his steps of his anger : (we all lost someone or something ten years ago) : the night is here : the city burns : the city burns with hunger for more : & there is never enough in this city : the city shines brilliant & hums its electric song, footsteps keeping beats : (we all lost someone or something in that war a lifetime ago) : there is never enough in this brilliant city : the city hungers : it can never conquer its hunger :

Day In, Day Out

Naming the Ship

Snow in Spring

11°41'50"N 165°16'19"E

: it is March 1, 1954 : it is March 1, 1954 early in the morning : it is March 1, 1954, & they have been looking for tuna for several weeks : north they went : south they went : & this is where they ended up : it is March 1, 1954, early in the morning : it is before breakfast, but for distant-sea fishermen, all hours are hours of fishing : & it happens : they look : the flash of white light : *pika* : the crew on the Lucky Dragon Five see the western horizon lit up like the world on fire : a sunrise, someone says, though the sun does not rise from the west : they cover their eyes : they see a white flash behind closed eyes : (where have they seen this? where have they heard this?) : the colors vibrating the air, swirling : red, yellow, then purple : the sea returns to darkness : the eerie silence as they look at each other : the world & the sea silent as the western horizon returns to the early morning darkness as the umbrella-shaped column rises to the sky like a fist of divinity punching the heaven : the calm : they look at each other : they know something has happened : they don't know but they know : then the *don* : the roar rides above the waves & slaps them : the sea underneath shaking, trembling, the waves suddenly rise & roll, tossing the small boat as if it were a toy ship : the dark cloud blankets their boat : then the rain : (where have they seen this? where have they heard this?) : then snow-white ashes : snow so thick they leave behind footprints where they stand : they know they have seen something they should not have seen : they have heard of a boat disappearing a year ago, something about the *American experiment* : they've heard of rumors through their radios & word-of-mouth about rumors : *the fallout* : they hurry : they hurry but they do not radio in, fearing that they might be sunk by *them* : they hurry home back to Yaizu Port : they hurry as quickly as they can : but it all starts : hair loss : bleeding gums : nausea & lethargy : their skin turns dark red as if roasted by the sun : what is happening to their bodies? they wonder as they sit on their hospital beds : the silent Geiger counter comes alive when it nears the men's bodies : doctors in Tokyo query the American government & they are met with silence : (where have they seen this? where have they heard this?) : *there might have been an experiment, but we can't tell you* : they lie in the hospital beds, minutes feel like hours & days feel like lifetimes : they feel worse : they feel better : money is given *ex gratia* by the American government : the Japanese government does not blame the Americans, no, never, why would they? : one man dies six months later : *it is not from radiation, but from underlying liver cirrhosis compounded by an infection : it is unreasonable to make such a big deal over the death of a fisherman*[13] : two doctors from America come but not to treat : just like their brother-doctors in Hiroshima & Nagasaki, they are there to record, to note, the camera keeps recording, recording blistered faces, balding heads, discoloration of the flesh & the Geiger count : (where have they seen this? where have they heard this?) : *atomic tunas* : we'll be back home soon, these men tell their wives : no one wants to touch them : no one wants to eat atomic tunas : (where have we seen this? where have we heard this?) : radioactive rain falls in Tokyo : the rain falls :

The Unlucky Ship

Suffocating Fish

Spring Again

A Man, Hiroshima, & Bikini Atoll

: he fought in the war : he fought & survived somehow & landed in Hiroshima : he survived & saw what had happened to Hiroshima : the city smelled of rotten meat & he thought he had seen it all during the war but Hiroshima went beyond what he could ever imagine men could do to each other : he remembers what he saw as he comes back to Tokyo & starts to work as a film director : he dreams of making a film about what he saw in Hiroshima : years pass while Americans tell the directors what films they can make, what films must be censored, & most are censored : but Hiroshima does not leave him : it's taken root inside of him & grows & grows like a deformed fetus : it grows inside of him, & though he is not a *hibakusha*, he keeps silent about what he's seen : Tokyo keeps moving forward : the war was lost because of technology, & technology is what will save us, the city sings : the man makes films : the scenes from Hiroshima appear & then disappear in his mind's eyes like a dream that he can't remember during the day : then, one day in April 1954, he watches the news : a small tuna-fishing boat came back from the South Sea, all its crew showing the signs of radiation sickness : the crew says that they saw *pika* : the crew says that they stood under *Shi no hai*—ashes of death—as they tried to gather nets & fishing reels to get away : & this overlaps with Hiroshima : this, all over again : & he thinks of a creature that lives in the depth of the sea : the creature is asleep like a baby in the womb : it has been asleep for millions of years : & one day, is awakened by… : a bomb, he thinks : yes, a bomb, a hydrogen bomb : he does not know what the monster looks like, only that it's a prehistoric creature : Tokyo flattened : technology wakens it : it cannot be domesticated : the most majestic creature on the land—the gorilla : the most divine creature in the sea, *kujira*—the whale : a creature is born : *gojira* : the divine, the destroyer, the avenger, the godlike : it rises from the sea : *Godzilla* :

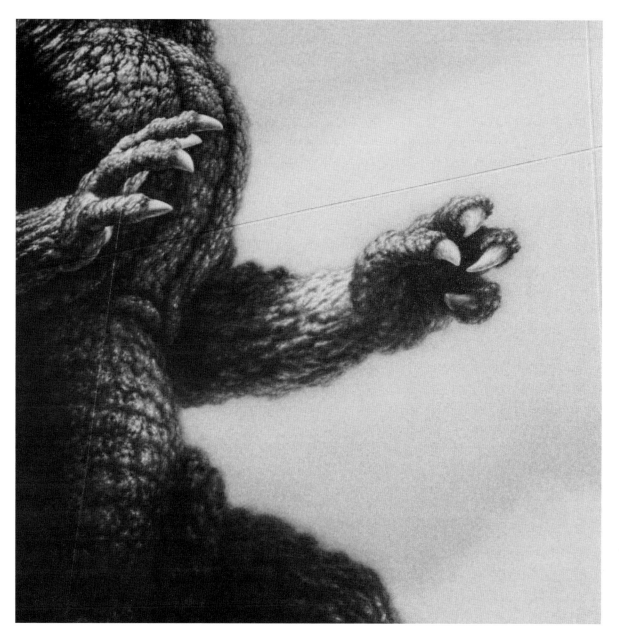

A Creature Awakens

Fish on the Street

Irradiated Engine

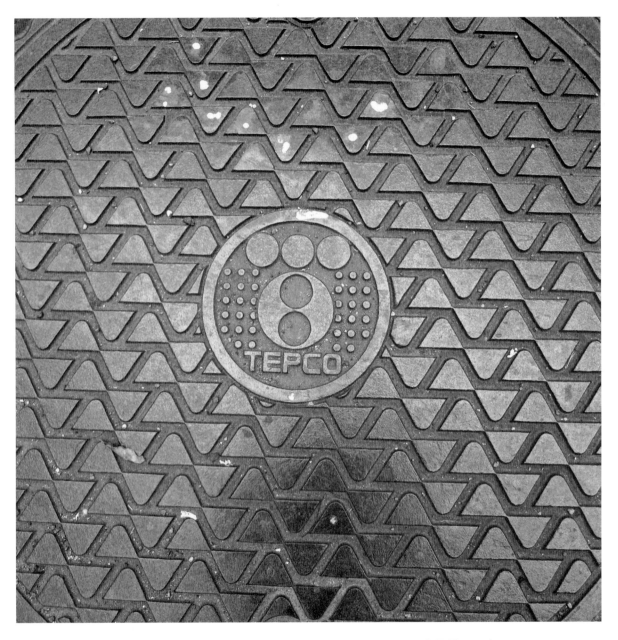

It Is Everywhere

How to Build Nuclear Power Plants

: it must be by the sea : it must be by a large body of water because the reactor requires a vast amount of water to cool down : it must be a poor land : it must be a land so desolate that people can barely farm : the sea must be choppy & not fit for fishing : it must be in an area where there are not enough jobs & men & women get on buses at the end of the harvest season, promising to bring back money in spring, leaving behind their children with the grandparents : it must be a place where they know what hunger is, & have sold their children & themselves in the past, just to survive one more season : it must be a place far away from the city : it must be a place far enough that dreams of riches are more real than the actual city : it must be a place where promises of riches will be drunk down like thirsty bodies : it must be a land where they think the city people are smarter than they can ever be, though inside of them, they know they can be as smart if given a chance : it must be a place where they hunger : hunger for better lives : hunger for jobs : hungry enough that they would work at a plant even if it means that their bodies might be destroyed in the process : it must be a place where they don't think of atomic bombs & Lucky Dragon Five whenever they hear the word, nuclear : it must be a place that believes in the goodness of the government : *it is for the national prosperity, your sacrifices are small compared to what Japan can be— economically rich* : it must be a place that will believe you when you tell them, *nuclear energy is a clean energy, no one has ever died from nuclear energy* : it must be a place where people are practical because practicality is how they have survived during lean months : it must be a land where when they see deformed fish, they will shrug & keep eating them : it must be a place that when you tell them you will build real roads & hospitals, & better schools, they will look at you (you think) in gratitude for the future now possible : you will tell them, *the area will be so rich, with so many people visiting this place, all the small businesses will benefit from the new plant* : the money will keep pouring in, it will, & there will be so many stipends from the government : people will believe you (you think) : people will drink your words, for they know how hard it is to live on the land (or so you think) : on this very land :

The Setting Town

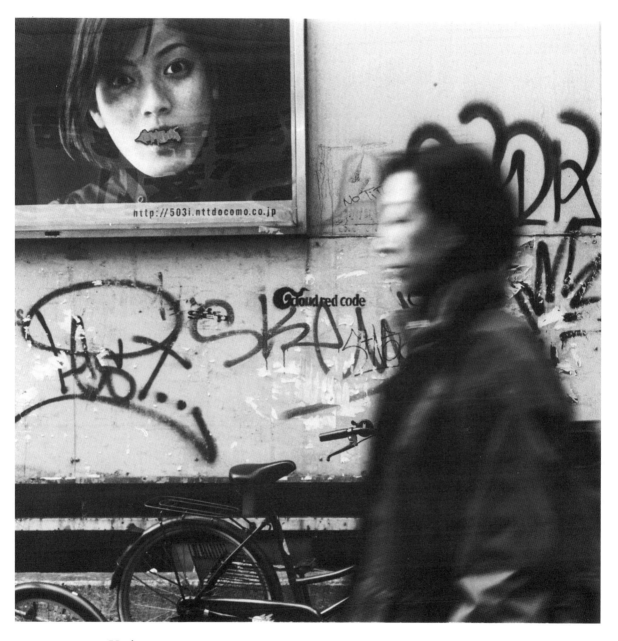

Hush

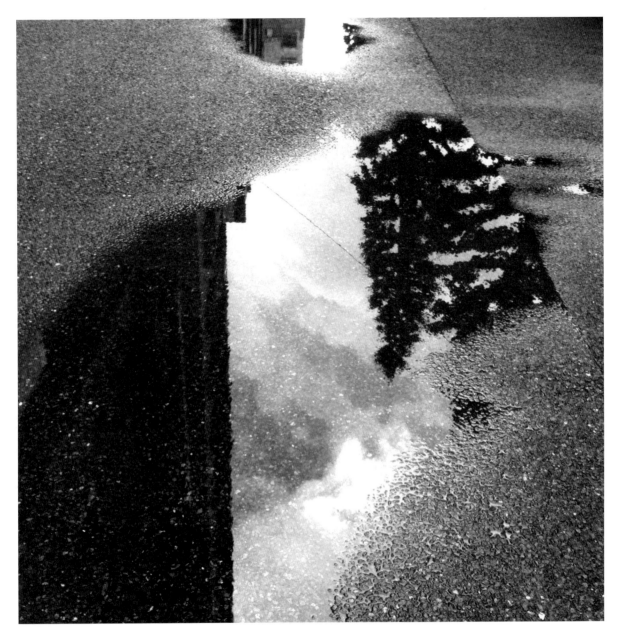

The World in the Puddle

A Good Era

: it is a good era : buildings are built : the war is a long-forgotten dream & men & women who talk of the war, outdated & dying : (Mutsu, a ghost ship with a faulty nuclear reactor, floats in the sea, harboring denied) : people dreamt of washing machines, refrigerators, & televisions ten years ago : now, everyone has them, if not just one, then two or three : in Hiroshima & Nagasaki, *hibakusha* remain quiet : women walk in mini-skirts : at a future nuclear power plant site, a man refuses to sell his land, the land his family has been on for generations : he is alone in his fight : his neighbors harass him, telling him that the village is dying, that he is killing the entire village by his refusal : Japanese are going abroad : Japanese are going abroad to stake a new empire, an empire built with technology & money : the crew members from the Lucky Dragon Five are dying slowly, one by one, but their deaths are ordinary deaths, or at least that's what the doctors say : *it is clean energy : it is abundant energy : it is cheap energy* : the fishermen get on their boats with all their colorful flags waving in the wind, yelling, *we don't want nuclear power plants, we don't want nuclear power plants* : they bang their sea-worn boats against the Coast Guards', they haul their boats to prevent the enemy from staking their claims to the sea : *this is our livelihood, we don't want contaminated water* : (Mutsu goes around & around the archipelago, unable to moor, unable to dock) : it is a good era : the young dance to American music : they protest against the distant war in Vietnam : then they grow up & put on suits & carry briefcases : days have gotten longer & longer, time elongated : neon pushes away the darkness : the entire island of Iwaishima has risen up, all five hundred residents, protesting against the building of a nuclear power plant 4 km away : workers at plants are quietly getting sick, leukemia, bleeding gums, bleeding noses, exhaustion, cancers : doctors tell them there is nothing wrong : (Mutsu goes around & around the archipelago, unable to moor, unable to dock) : factories run all day long : factories hum all night long : a man is coaxed, bribed, blackmailed, threatened to give up his land but he never says yes : children here & there are born with defects near nuclear power plants, but no doctor will ever say it is because of the plant, they tell mothers, *it's genetic, it's coincidence, your children are malnourished* : day laborers get in a van one morning & don't come back for days or weeks or months : & when they do, they are skinnier, sick & quiet : a rumor of having worked at the nuclear power plants : (Mutsu goes around & around the land, unable to land, unwanted) : the night is brilliant in Tokyo : people dream of going there, living there, where all dreams will come true, where all can live the life that they were meant to live : it is a good era :

It Is Time to Go Home

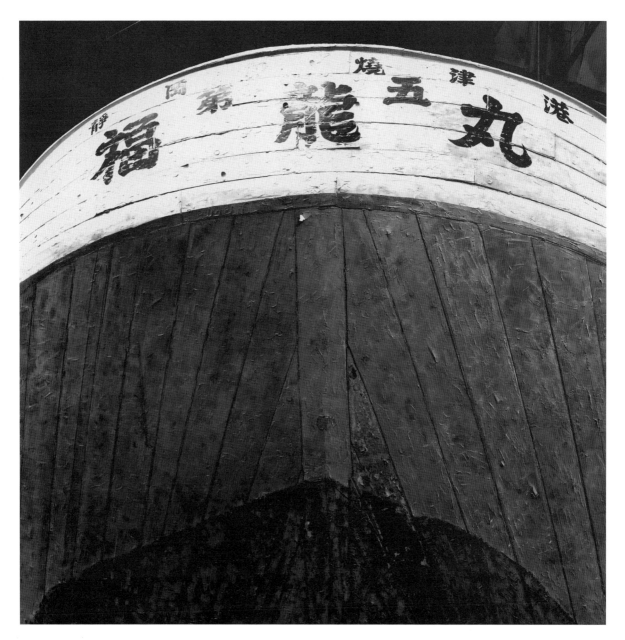

An Echo from the Past

Scattered Light

Eighty-Three Days in 1999

: a body lies : a body lies in the hospital bed : the first body in Japan to have survived a criticality accident, a bucketful of uranium carried just as it is, uncovered & unprotected : this body carries with him nearly twenty sievert of radiation : the body should have collapsed under so much radiation : the body should have broken down already & it already is, one cell at a time : doctors are excited : this is the first live body they can examine : the first irradiated body : a specimen : *only twenty cases in the past* : just as they have read in the textbooks : the irradiated body lies on the hospital bed : it still talks : it talks as the body bloats, metamorphosizes into an impossible : how long does a body last carrying twenty sievert of radiation? : how long can a body last? : the skin peels off : the cells transform into unrecognizable patterns : his family waits, time measured by paper cranes folded into prayers : doctors know that this is a losing battle from the start : a body this broken is close to the end : how long can a body last with intervention? : how long can they keep it alive? : the body begs for water : the body yells out : *please stop, I can't take this anymore : I want to go home : I'm not a lab mouse*[14] : it thirsts : it yells out : it rejects water : it rejects grafting : it rejects blood transfusion : blisters erupt like molten volcanoes : skin peels off an inch at a time : nails come off : doctors take away its voice when they insert the artificial oxygen tube : what is medicine? doctors ask themselves : what is this treatment they are administering to keep a man alive? : to keep a body alive just so they can measure its decay & pain every half an hour : who are they doing this for? doctors ask themselves : is it for this irradiated man? : is it for his family who wordlessly fold paper cranes in the waiting room? : is it for themselves? ask the doctors : everything is shut & what sustains this body, what carries it afloat, are tubes, tubes coming out & going into the body, it looks like a spider sitting in the middle of a web : the man is no longer there : this is only a body : a body suspended between here & the other world : doctors monitor each decay the body goes through : organs are dead : the body rejects all : how long can a body last? : it can last eighty-three days : it lasted eighty-three days until it had enough : this is how long an irradiated body can last :

A Room at Twilight

Between Worlds

Stillness

Rumors of Distant Disasters

: on a distant shore : it all happens on the distant shore : somewhere in a place called Three Mile Island, residents pack up their children into buses for evacuation : somewhere in a place called Three Mile Island, somewhere in the state called Pennsylvania, people hold their breath behind closed curtains : children on a distant shore, Bert the Turtle teaches children to duck & cover : here, on this shore, another nuclear power plant is built far away from a city & the city demands more & more electricity to keep it going, blood pumped from the heart : a ghost ship circles the archipelago, at home in its homelessness : somewhere on a distant shore called Goldsboro, North Carolina, two hydrogen bombs fell from the sky, landing on small farms & one of them still lies deep in the earth, contained in its sleep : bombs are detonated all over desolate places, lands made more barren & dangerous, for whom, to whom, it is for the constructed enemy : all on the distant shores : on a distant shore called Chernobyl, behind the Iron Curtain, a nuclear reactor melts down by accident, & residents are told to pack up three days' worth of clothing : an old woman packs her cat : they believe that they can go home in three days : some stay behind : & in a distant city, they begin to get sick, sick, all over again, while the government tells the people & the rest of the world that all is well : on a distant shore, pigs & sheep are tied to the poles, families of mannequins sit by the dinner table, enjoying their imaginary dinner : on this shore, a nuclear power facility worker in Tokai-mura fills his bucket with uranium, spills it & the residents within the 350 m radius are told to evacuate & the rest to stay put, to stay put, the accident is contained, it is manmade, it is not a meltdown : on a distant shore, a government is making hundreds & hundreds of suns, to reorder the politics of the world : on this shore, all is well : because they tell themselves : on a distant shore : it all happens on the distant shore : it can never happen here :

The Other World

Night, Again

Notes

The quote in the subtitle of the 'Tokyo' section, "It Is No Longer the Postwar," is a translated phrase taken from the 1955 Economic White Paper published by the Japanese Government. Photos were taken at various places in Tokyo between 2011– 2015.

13. Edward Teller, father of the hydrogen bomb and architect of the Marshall Island tests. Quoted in Hoffman, Michael, "Forgotten atrocity of the atomic age," *Japan Times*, August 28, 2011 (11).
14. NHK Shuzaihan. *Hibakuchiryou 83nichikan no Kiroku (A Record of 83 Days of Radiation Treatment)*. Tokyo: Iwanami Shoten (55). 『被爆治療 83日間の記録』ＮＨＫ取材班　岩波書店 (55).

FUKUSHIMA

<<All the Waste in a Year from a Nuclear Power Plant
Can Be Stored Under a Desk>>

From Fukushima, with Love

Before the Beginning

: *Hamadori*, the land along the shore of Fukushima where the land crashes with the unforgiving Pacific : this was a poor land : made poorer by the wind carving out the shore : made poorer by the salty wind that sliced away layers of fertile soil : men have farmed on this meager land as long as they can remember : their bodies molded into the shape of labor, their bodies molded by the backbreaking labor that they lived through all seasons : but this is not the pastoral land of Virgil or Hiroshige : the only song this land sings is the lull of the sea : every child remembers every fall, right after the harvest, fathers & mothers packed up small bags to work in cities : that's how they knew winter was just around the corner : winter was deep & long : winter in this land was of children & the old, trapped inside by the wind from the sea : spring came late : it came & went quickly : in late spring & early summer, they made their industry out of silkworms & papers where trees could take root : they raised silkworms to spin so that people in big cities could wear the woven textiles & made papers that they never used : they raised what they could raise : they knew winter was long & they had to be vigilant for the supplies of food : & in the worst years, when things became scarce, well, there are always girls to sell : nights came early & stayed long enough, nights were dark, illuminated by one single light of oil or candle : then, during the war in Ishikawa, men from the big city found palm-sized rocks with yellow veins : they didn't say that there was so much power within that rock : women & children were told to dig the hill, they worked from eight in the morning until four in the afternoon without rest : *with their bare hands* : for the nation : a lab opened up : a military officer came from Tokyo & told them, *the rocks you are collecting can be made into a bomb the size of a matchbook powerful enough to utterly destroy New York*[15] : but soon enough two bombs fell from the sky, & the war ended, & there was no more need for that secret rock : the wind blew from the sea : it blew & carved out the shore : it blew & made waves harsh : they looked to the capital & riches that were beyond their reach : another fall came : men began to look at their small bags & knew that mines & construction sites awaited them : but this year, a group of men came : they came & surveyed the land : then next year, they came back : they said that they wanted to build a nuclear power plant : a nuclear power plant to provide electricity to the capital : that if the plant was here, they would be supporting the advancement of the nation : the men in suits came with promises : schools & better roads & jobs : men would never have to leave the family, ever again : there would be so many people come into the town, & they'd drop money on hotels, restaurants, grocery shops : electricity would be free : the men from the capital said that they'd buy all the land, that good-for-nothing land that didn't produce : a nuclear power plant, *it is safe, it is an American technology, no, it's not the same as atomic bombs, it's better, it's safer, it's cheap* : & one by one, people began to sell their land, households with sick & the elderly, the ones who needed money the most : most resisted : this may be a meager land, but this is our families' land, they said : but in the end, they all sold the land : & just like the promises, money did come in, & their lives became easier :

Promise of Radium, Promise of an Atomic Bomb

27 km from the Beginning

A Worker's Jacket

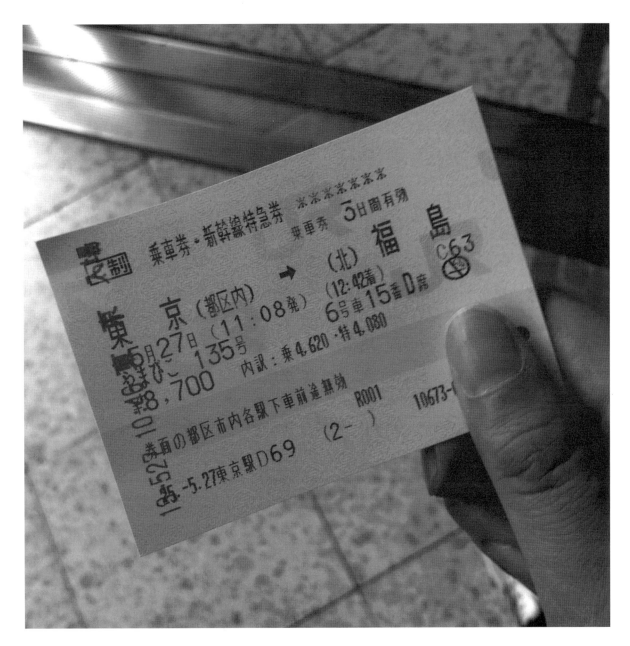

Tokyo to Fukushima to Tokyo

Kaitensushi Atom, Atom Tourism, Nuclear Power Plant Sweets, Radium Eggs

: as good as their words, lives became better : jobs at the plant meant men no longer had to pack their bags at the end of the harvest season to look for jobs in the cities : money poured in from all sides, money from the government, taxes from the plant, outside workers pouring in money in bars, restaurants, into the area : *if you work hard, then your family, your company, your community, and the entire nation can be rich* : men from Tokyo come : men with education, with intelligence, with smooth words & loneliness, & the girls dream of marrying such a man : smartest boys from the local high schools work there : families are proud : *it is safe, it is clean* : a woman says, *we unconsciously avoid talking about the nuclear power plant, I remember we all became quiet when an anti-nuclear demonstration marched in front of our school, even as a child, I knew we shouldn't talk about it*[16] : no one had to leave the land for winter : there were trains & buses : train stations lit late in the night, just like in big cities, the shopping arcade brilliant with light : houses turned from thatched roofs to tiles : within the plant, it turned into a little America : the GE Village : with American engineers & their families, bringing with them the luxuries of the American life they'd only seen in movies & magazines : *steaks, Coca-Cola bottles, Christmas parties with a real white Santa Claus, Halloween parties with children in costumes*[17] : prices increased & so did their dreams : before the nuclear plant, their dreams could fit in the palm of their hands : now, they knew what they could have : sometimes, protesters came from far away cities but the nuclear villagers looked at them suspiciously : *it's easy for you to say you don't want nuclear power plants, you don't have it on your land : it's easy for you to be anti-nuclear, but where do you think you are getting your electricity?* : Kaitensushi Atom, Atom Tourism, Nuclear Power Plant Sweets, Radium Eggs : *new trends in Futaba—bars, boarding houses, lunch take-outs, peeping toms, rapes & violence, assaults, pollution, contamination, lies, men with fat wads of cash, women asking where the fish came from*[18] : hospitals & schools & libraries : smooth roads & buildings : no one has heard of anyone they know going into dangerous places, only specialists & foreigners go in : (that's what they've been told) : *there are people who are against it, but those people are eccentric, you know*[19] : money keeps pouring in : TEPCO is the new lord, the benevolent ruler of the area : Kaitensushi Atom, Atom Tourism, Nuclear Power Plant Sweets, Radium Eggs : the future is theirs :

Towels & an Umbrella

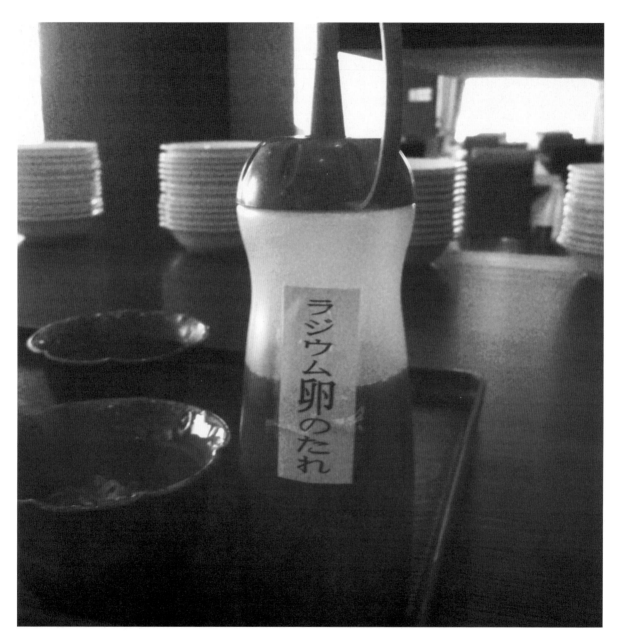

More Sauce for My Radium Egg, Please

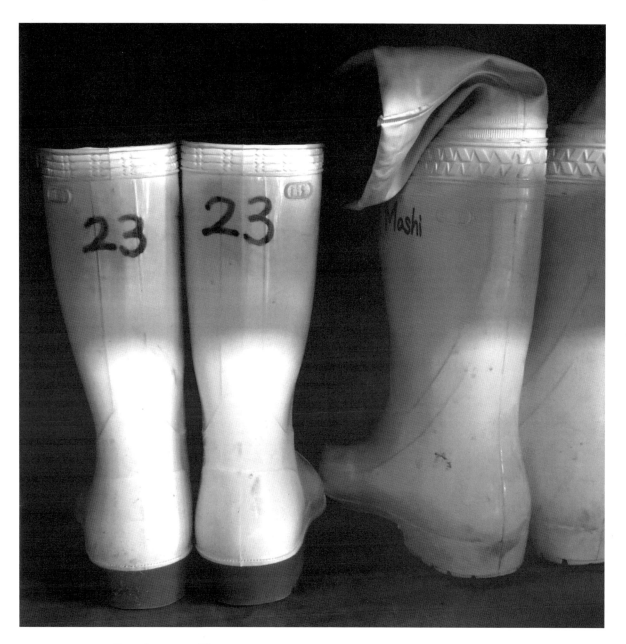

Farm Boots at a Temporary Dairy Farm

Twenty-Four Hours

: it is always beautiful on a catastrophic day : it is beautiful because the *before* is beautiful & the *after* dreadful : it is a beautiful day because it must be : it is still late in the winter, early spring : the earth trembles, then shakes, the earth turned upside down, or so it seems : it keeps shaking & shaking : people crouch on the floor, waiting for the earth to still, but it keeps trembling as if they are on a ship on a stormy night : books fall : dishes shatter : ordinary pieces of furniture turn into weapons (just like *that* day, so long ago) : in Ichi-Efu, nuclear reactors 1, 2, & 3 shut down automatically as they should : electricity shuts down : phone lines go down : backup diesel power generator kicks in : the earth keeps shaking erratically : (if there's an earthquake, there's always a tsunami, that's what the stones say) : some people remember the sayings of their ancestors, always remember this : *tsunami tendeko* : if there's a tsunami, don't take anything with you, don't worry about your relatives, run to a high place on your own, protect your own life : some go looking for their loved ones : some stay where they are, thinking that it's like any other earthquake : so many cars on the road : some amble up the hill, thinking all will be over in an hour : an announcement blares as the waves approach the coast : *this is a tsunami warning : evacuate from the coastal area as quickly as you can* : some go to the sea to watch : a car drives as fast as it can, almost making it out, then disappearing into the sea : the first wave strikes Ichi-Efu : a nearly 15 m tsunami rides over the seawall & the seawater disables the backup generators : the systems start to fail, one by one : people huddle atop hills & buildings, & below them, their towns swallowed up by water : (where have they seen this? Was it one of the Godzilla films they saw growing up?) : cars carried by the sea : they wonder if the rest of Japan is the same, the entire nation under water : they watch as burning houses rush by : people huddle atop buildings : the sea is all around them, the towns are under the waves : the sea keeps roaring in the dark & bodies are pushed back into the sea (just like *that* day, so long ago, when bodies returned to the sea where they came from) : evacuation order within 3 km from the nuclear power plant issued : people on the hills wait to be rescued : but around the plant, those who survived start looking for their loved ones, wading through shoulder-high waters, calling to them, calling their names : a woman could feel her mother in her arms getting colder & colder as the night deepened & the sea returned to its original place, calmed : people wait on rooftops, on hills, in buildings, waiting for the help that should have been here so many hours ago : the temperature drops : the snow begins to fall from above, white sky glowing red from burning houses : there is something wrong, people know : no one can get through, no one from the plant is heard from : people within 10 km of Daiichi are told to pack what they can : buses like an elephant herd wade through the devastated landscape : locking their doors, leaving their dogs leashed, the missing left behind : the sea is full of dead bodies : bodies beach up : bodies caught in unlikely places, on trees, atop houses, bodies left behind : *it's safe*, they were told again

& again : *it's safe, nuclear power plants are safe* : (where have they heard this before? Where have they seen this before?) : in the distant shore : on this shore :

To Tokyo

Hands Tell One Story While the Mouth Tells Another

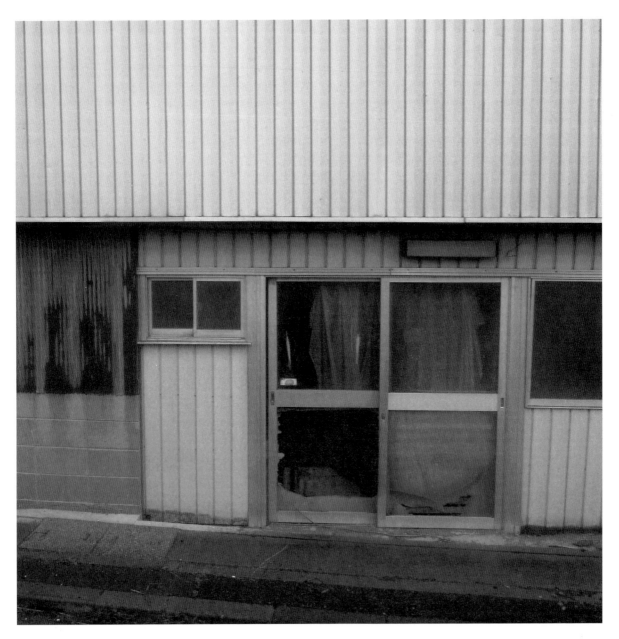

Shattered Window

The Displaced

: their homes inside the Circle stopped *that* day : the pot of soup still on the stove top, filmed with molds : dead dogs leashed still, their ribcages like washboards : doors locked : calendars all blank after *March 11* : claw marks on walls & cats curled up in death : & they live in hotel rooms, in gyms, in hospitals : their clothes second-hand sent from all over the world, clothing that stank of someone else's sweat & dreams : standing in lines, hour after hour : standing in line to eat : standing in line to use the toilets : they are forced to endure hours of songs of the well-meaning singers : they are told they may be able to go back soon : cows, still in their stalls, moan from heavy udders & caving stomachs : & in the Circle, peacocks strut the empty streets, pigs run around in herds attacking dogs : journalists go through the evacuation sites, taking footage of their private moments : *how do you feel? tell us how you feel right now?* : they get boxes & boxes of cosmetics from cosmetic companies, *women need to feel beautiful in the time of stress, after all they are women, that's what they want* : a woman does not move from her one mat-sized space : privacy is a privilege, & there is none here : within the Circle a man lives in his half-damaged house, *I'm too old to move, if the radiation gets me, I don't have long to live anyways* : ostriches run feral on the streets & so do dogs : the displaced stand in line to prove who they are, they know who they are, but they become anonymous without proof : stretchers scatter the hospital driveway : at night, people pull covers over their heads to domesticate their fears & dreams & cries : dairy farmers up north put their last cows into the slaughterhouse truck, *no one told us that the hays were irradiated, no one told us that milk from our cows are irradiated* : there is always someone awake at night : there are many awake at night, though they don't know it : kindness is pushed on them : well-meaning gestures are supposed to be accepted : *what do we want?* : days turn into weeks : hours turn into years : a dairy farmer hangs himself in the barn, *my legs & arms were torn off by the nuclear power plant, I'm so sorry that I wasn't a good enough father to you,* leaving behind messages on the wall of his house that hasn't been paid off[20] : time seems to be linear but everything is temporary : bodies from the tsunami rot on streets : their fathers & sons are still working at the plant, needles in their Geiger counter stuck to the right beyond the red, beeping every other minute & they sweat inside of their suits : someone tells the child to shut up, *he needs to sleep* : dogs form packs : volunteers come : volunteers leave : new ones come : new ones leave : evacuees must stay : they look for the missing in other evacuation sites : within months, houses look abandoned : dogs on leashes die where they were tied : journalists come with swaggers, taking footage without their permission, & the sadder the better because tragedy sells, tragedy is familiar in their language : they come & ask, *how do you feel? tell us how you feel,* & taking people's words, they leave : their homes inside the Circle have stopped : the displaced must stay where they are, just like the dogs they were forced to leave behind, tied to the beams, *I'll be back, I promise* :

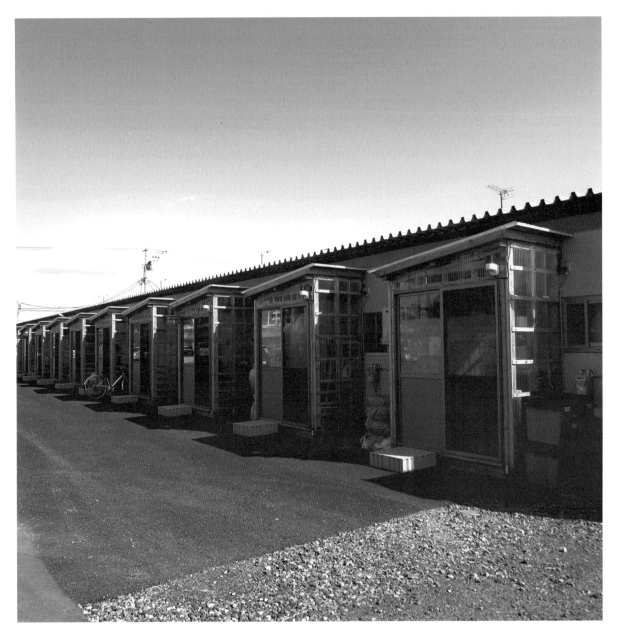

Temporary Life, Temporary Home

Looking for Workers

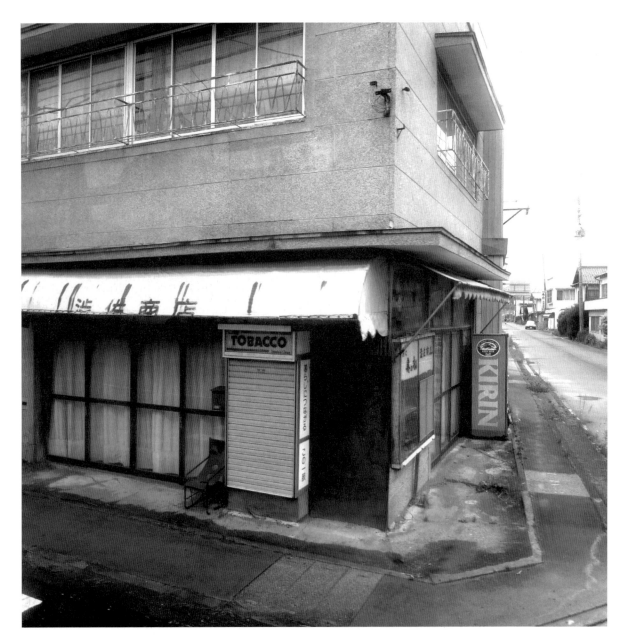

An Abandoned Town

A Rice Field Two Years Later

Sky Over Fukushima

Things People Say

: don't eat anything from Fukushima : people from *there* are irradiated : so nice you can live in hotels : people are going home, why aren't you? : the radiation levels near the plant aren't that bad : the radiation level is really bad, you should move away as soon as you can : you must be getting a lot of compensation money from TEPCO : go home to Fukushima & stay there : we should buy produce from Fukushima to show our support : you moved from there to Okinawa? you are just being paranoid : if you decontaminate the soil, you can go back : how can you think of living in Fukushima when you have children, you're a bad mother : if the government is saying that it's safe, I don't know why you are staying at the evacuation site : Fukushima got employment benefits, they got nice roads & hospitals & all the benefits from having a nuclear power plant in their area : you're so lucky, you don't have to work anymore : people are going back to rebuild their homes but you are just running away : there is no abnormality in the thyroid cancer rate in Fukushima : there is an abnormal spike in thyroid cancer rate in Fukushima : no more nuclear power plant : you got a lot of money when the plants were built, you knew the risk but you wanted money more : the plant is under control : these people near the nuclear power plants are ignorant, they don't know anything about the danger of meltdown : it's criminal to keep fishing from the sea : don't drink milk from Fukushima : you're thinking too much about this : you're not thinking too much about this : don't believe a word TEPCO tells you : you're lucky, you don't have to work, you're earning a lot more money than you did as a farmer : more than 400,000 people will die in the next decade : don't marry anyone from Fukushima, you remember what happened to babies in Hiroshima & Nagasaki : you've been brainwashed by TEPCO to believe that it's all safe : it's safe to let your children play outside : it's not safe to let your children play outside : no one has ever died from a meltdown : cancer rates will spike in Fukushima : babies with birth defects will rise & rise : it's criminal to keep farming & selling your produce : Fukushima wanted nuclear power plants : look at these people, even after a year, they are living off of the compensation money, they aren't even looking for jobs : people in Fukushima are so resilient, they know how to go through adversities without complaints : there is no meltdown : there was a meltdown, but all is well now : you can go home in five years : you can go home in twenty years : think of the children, leave as quickly as you can : the nuclear power plant should keep running : nuclear power plants are necessary for Japan : you must be getting rich, aren't you? : you can trust the government : you can go home : you can never go home :

東京電力からのお詫び

に発生した東北地方太平洋沖地震により、

なられた方々のご冥福を衷心よりお祈り申し上げ

受けられた皆さまに、

を申し上げます。

京子力発電所における事故、

の漏えいなどにより、発電所の周辺地

らに広く社会の皆さまに大変なご心配

申し上げます。

We Apologize for the Inconvenience

The Last Stop Before the Circle

The Proof of Safety

Temporary Homecoming

: park here : stop here : put this on : plastic shoes, plastic overalls, face masks & plastic goggles : plastic bags : put on goggles : masks : the Guards herd them on buses : the Guards stand by the barrier of the Circle, they are the ones who keep the otherworld at bay : the Guards in masks, their faces anonymous, guide the traffic : no one speaks : they see it : roads overrun with weeds & vegetation : cracked roads : houses half toppling over : roads empty except for the buses : their fields overrun with grass, feral, & they know it would take them many years to domesticate these lands, if they ever go back : crows land en masse, the black creature & something in the middle : they are given two hours : they take what they can grab, things that matter to them, things that give meaning to who they are : photos : ancestors' tablets : the dead husband's treasure : some unleash their dogs : some keep their dogs leashed, promising that they will be back in a week : the garden they so loved is no longer a garden : houses stand in ruin, the life gone from their bones : they are herded back on the bus : they take the same road back : the barrier : outside of the Circle : they sigh in relief into their masks : the Guards herd them into a tent, where they are told to stand still : they stand still as the Geiger counter measures how much radiation they are carrying with them : a loud beep goes off : their hearts pound : they are told to throw away all that they are wearing into a plastic bag : stop here : take this off : their lives measured by the Geiger counter, by the merciless needles :

Decontaminated Soil

The Last Stop

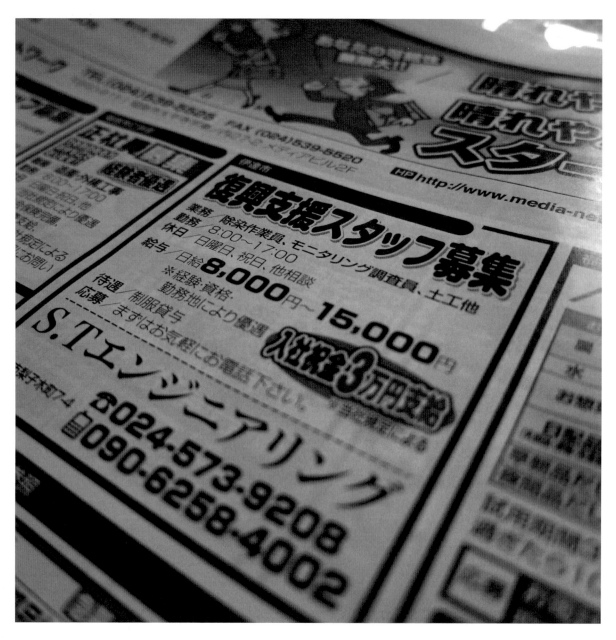

Reconstruction Assistant Staff Wanted

Truth & Lies

: there was no meltdown : no one has died from the Daiichi Fukushima Nuclear Power Plant *incident* : 400,000 people will die from this : the polluted cooling water was never released into the ocean : (what is the truth? what is a lie?) : there was a meltdown, TEPCO & the government knew about it immediately : you can go home as soon as the land is decontaminated : this is the worst nuclear power plant accident in the history of mankind : it is Level 5 in the nuclear accident rating : children will develop thyroid cancer from being exposed to the windfall : (what is the truth? what is a lie?) : emergency evacuation preparation zone is only voluntary evacuation, there is no compensation : it is safe to live there, the body can withstand 20 uSV/h : radiation is contagious : babies were irradiated in utero, they will be deformed, just like babies from Hiroshima & Nagasaki : you can go home in five years : there is no correlation between being irradiated & cancer : it depends on so many factors : one's chosen lifestyle, genetics, family history : (what is the truth? what is a lie?) : the government never lies : people decontaminate the radiation monitoring post, that's why it's so low : they make up a low radiation dosage : there were so many birds that summer right after *that* day, they were pecking dead bodies : there were no birds, they all died from radiation : the rate of radiation on fish from the coast of Fukushima is high : the food from Fukushima is safe to eat : nuclear power plants are safe : (what is the truth? what is a lie?) : plant sunflowers, they will accelerate the decontamination of the soil : people from that area wanted nuclear power plants, they knew the risk : the meltdown was worse than Chernobyl : once the soil is decontaminated, you can go home : TEPCO is hiding the truth : as of May 2013, 1,383 people from Fukushima had died : Fukushima wanted nuclear power plants : it is safe for children to play outside & have a normal life : (what is the truth? what is a lie?) : bees disappeared & so did other insects right after March 11 : as long as there are Asiatic dayflowers in their gardens, people are safe : no one in Fukushima wanted nuclear power plants : Fukushima people are resilient : in Hiroshima & Nagasaki, people with more than 6 uSv/h died : the Lucky Dragon Five men with more than 5 uSv/h died : flying in air causes you to accumulate more radiation than the rate in Fukushima : unless you get more than 50 uSv/h, you don't have to worry about cancer or leukemia : (what is the truth? what is a lie?) : there is no correlation between miscarriage & irradiation : people get sick from radiation stress : people in Tokyo & the media are overreacting : there was no meltdown : there was a meltdown, one of the worst in the history of humankind : (what is the truth? what is a lie?) :

A Dairy Farmer from Iidate Village

A Ghost Hamlet

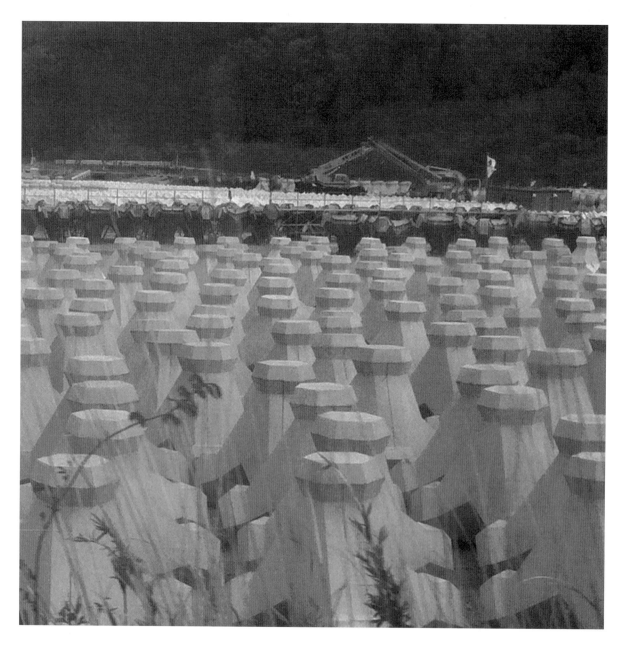

Breakwaters

Before the After

: it is the last note that still lingers in the air : even after five years, the last note still lingers in the air : no : it's five years, & the music is still playing : people live in temporary housing : they live in temporary times : it's been two years : it's been three years : a woman begs & begs her husband to take her home, & sets herself on fire on the temporary homecoming in the garden she so loved, & she is worth 49 million yen[21] : the *after* is what they are looking for but there is no *after* in this place : Fukushima is now a synonym for Hiroshima : Fukushima is now remembered : 福島 the island of fortune : now フクシマ burdened with meanings, both truth & lies : a woman waits at a free thyroid testing center & whispers again & again, *I wish I could get sick just so that people would believe me about the radiation* : a prayer for her wish : a chant : another woman holds her child close : *I am so tired of being scared, I am so tired of wondering if I'm going to get sick* : a man & a wife, married longer now than they have been apart, shovel the contaminated soil : *we've been doing this as often as we can for the past five years, it's clean, it's decontaminated* : but they can't stay here, they want to stay here, but they can't : trees have been cut down, acres & acres of polluted soil in black bags weighed down by rocks : no one wants this radioactive soil so they remain here, in Fukushima, in the land where it all started : just like nuclear power plants : no one wants it in their cities : no one wants it : it's been five years : in Tokyo, they switch on lights, switch off, they consume : they have forgotten : they have moved on : *do you know how it angers me everytime I go to Tokyo, & streets are so bright at night, & people walk around as if nothing had happened while I am still living it, I am still in Fukushima, I still live with the fear of irradiation* : in temporary housing, it is only the old who have stayed : they have nowhere to go : they have no families : they are dying of loneliness & homesickness, one by one, but people call it *temporary housing illness* & let them die alone : polluted waters leak into the sea still : people are still displaced : lives have been interrupted, they are still paused from March 11, 2011 : homes frozen in time : streets still unwalkable & uninhabitable : a journalist says, *everything that needs to be said about Fukushima's been said, what else is new?* : in Tokyo, people marched for anti-nuclear power plants for a while, they texted & used electricity to carry out their messages : then new issues arise, they demonstrate for newer issues : nuclear wastes still go to Rokkasho-mura : people still die from *temporary housing illness* (or is it broken heart) even after five years : trains in the morning look like a Chinatown fish tank, crammed fish struggling for air & space & mercy : a woman says, *I want to go home* : & people do : *I'm going to die soon anyways, I want to die at home* : home behind the Circle : home within the Circle on the map : how long can this last? : how long until we run out of notes in the music? : here, in Fukushima, there is no *after* : there is no *after* & *everafter* in this land of the fortune, in this land by the sea, in the land of the displaced : not yet : maybe not for a very long time : it has been a year : it has been two years : it has been four years : it has been five years : we are still in the *before* the *after* : *before* the *before* the *after* ::

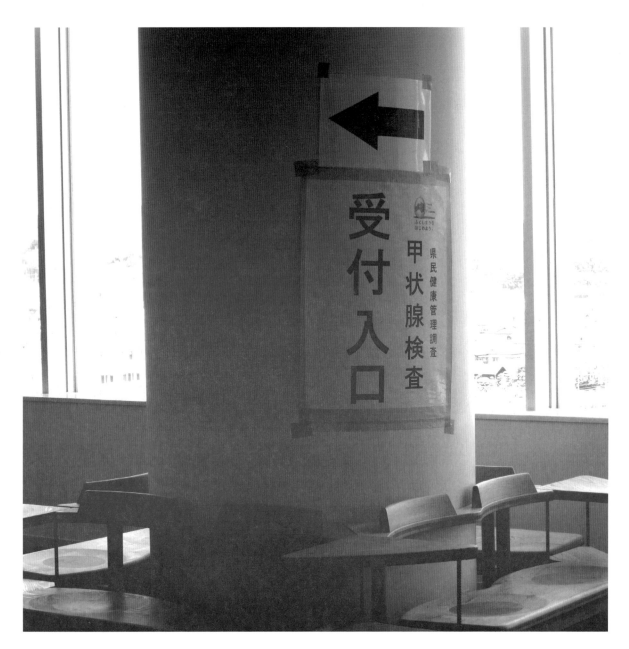

This Way to the Thyroid Examination

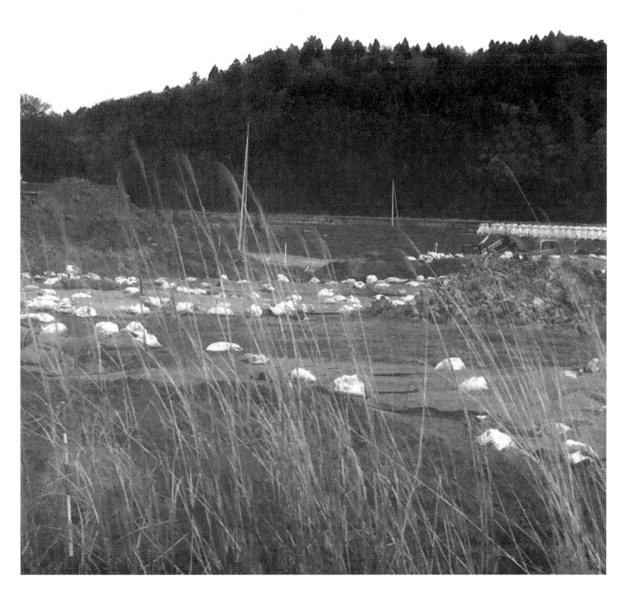

Contaminated Earth

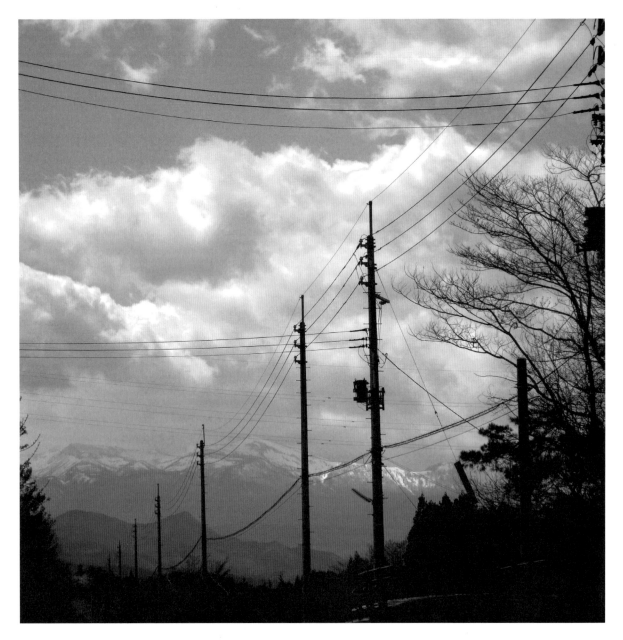

This Is Not the After

Notes

The quote in the subtitle of the Fukushima section, "All the Waste in a Year from a Nuclear Power Plant can be Stored under a Desk," is a quote attributed to Ronald Reagan. Photos were taken at various places in Fukushima in 2013 – 2014.

15. http://www.tv-asahi.co.jp/genbaku/introduction02.html
16. Kainuma, Hiroshi. *Fukushima-ron: Genshimura wa Naze Umaretanoka (Fukushima-ism: The Birth of a Nuclear Village)*. Tokyo: Seidosha, 2011 (103). 開沼博『「フクシマ」論　原子村はなぜ生まれたのか』青土社　2011 (103).
17. ibid. (280).
18. Kamata, Satoshi. *Nihon no Genpatsu Kikenchitai (Japan's Dangerous Nuclear Areas)*. Tokyo: Shinpusha, 2006 (111). 鎌田慧『日本の原発危険地帯』新風舎　2006 (111).
19. Kainuma, Hiroshi. *Fukushima-ron: Genshimura wa Naze Umaretanoka (Fukushima-ism: The Birth of a Nuclear Village)*. Tokyo: Seidosha, 2011 (118). 開沼博『「フクシマ」論　原子村はなぜ生まれたのか』青土社　2011 (118).
20. http://www.asahi.com/special/10005/TKY201106190452.html
21. http://www.huffingtonpost.jp/2014/08/26/fukushima-daiichi-nuclear-power-plant-suicide_n_5713387.html

Acknowledgements

The idea of this work was conceived, meditated upon, and written during the following art residencies which offered generous gifts of time, food, and laughter: Akademie Schloss Solitude (Germany), the Mesa Refuge (California), Sangam House (Bangalore, India), Ventspils House (Ventspils, Latvia), H.A.L.D. /Danish Center for Writers and Translators, Willapa Bay A.I.R (Oregon), and the Women's International Study Center (New Mexico). Special thanks go to Susan Tillett, Director of the Mesa Refuge, Cyndy Hayward, Founder of the Willapa Bay A.I.R, and Arshia Shattar, the founder and director of the Sangam House, for their fierce vision and for bringing together an amazing group of writers, artists, and thinkers. Hong Kong Baptist University offered me a generous month as a writer-in-residence, where I read many of these texts for the first time in public.

Excerpts from this work have appeared in *Stoneboat Journal* and *Asia Literary Review*. Martin Alexander, the Editor-in-Chief of *ALR*, has been a big champion of this work.

The following institutions granted me access to their staff, archives, and time to ask simple questions: RERF in Hiroshima and Nagasaki; Hiroshima City and Prefectural Libraries; Nagasaki University; Nagasaki City and Prefectural Libraries; and two anonymous temporary housings in Kouriyama City and its surrounding area; Fukushima City and Prefectural Libraries. As always, I am grateful to Tom Boardman and staff at Temple University Japan Campus Library who ordered obscure articles without question. Temple University Japan Campus has been my home, nurturing me, giving me a research semester off every year as well as financial support to pursue my interests for the last seventeen years.

I am grateful for the following friends, who have encouraged me, both directly and indirectly, while researching, interviewing, photographing and writing this project: Mari L'Esperance for her wisdom; Dorthe Nors, the wise woman of the northern Danish coast; fellows at the Sangam House—Rahul, Sally, Karthika, Raghu, and Karin; Celia Lowenstein, my new sister; Amy Kirsten for her music; Silvia Pareschi for her love of science & sense of humor; Bo Jacobs; Jon Wu for his patient ears & encyclopedic knowledge on everything from the rise of punk music to comics to K-drama to science to grammar. And most of all, to strangers I met in Hiroshima, Nagasaki, and Fukushima who shared their personal stories with me, who, on benches, at parks, at stations, on streets, approached me for no reason except to share their stories; and to my mother who doesn't quite understand what I do, but has let me disappear, again and again, to pursue this project and many others.

About the Author

Born in Tokyo, Japan and raised in Europe and America, Mariko Nagai has received fellowships from the Rockefeller Foundation Bellagio Center, UNESCO-Aschberg Bursaries for the Arts, Akademie Schloss Solitude among others and has won the Pushcart Prizes for both poetry and fiction. Nagai is the author of *Histories of Bodies: Poems* (2007), *Georgic: Stories* (2010), *Instructions for the Living* (2012), and *Dust of Eden: A Novel* (2014). Her work has been translated into Bulgarian, Chinese, French, German, Japanese, Romanian, and Vietnamese. She translates modern Japanese women poets into English, and currently lives in Tokyo where she is the Director of Research and Associate Professor at Temple University Japan Campus.